Postca

Bartlesville
Oklahoma

Postcard History Series

Bartlesville
Oklahoma

Karen Smith Woods

Copyright © 1999 by Karen Smith Woods
ISBN 978-0-7385-0310-3

Published by Arcadia Publishing
Charleston, South Carolina

Printed in the United States of America

Library of Congress Catalog Card Number: 99066666

For all general information contact Arcadia Publishing at:
Telephone 843-853-2070
Fax 843-853-0044
E-mail sales@arcadiapublishing.com
For customer service and orders:
Toll-Free 1-888-313-2665

Visit us on the Internet at www.arcadiapublishing.com

Contents

Acknowledgments 6

Introduction 7

1. Schools and Churches 9

2. Entertainment 27

3. Oil and the Osage 47

4. Buildings and Businesses 65

5. Street Scenes 87

6. Pioneers 107

Bibliography 127

ACKNOWLEDGMENTS

Thanks to Mary R.M. Nunneley for her dedication in organizing the hundreds of postcards in the museum's collection, for assisting in the selection of postcards for this book, and for the many hours of research to provide captions. Thanks to Mary R. Campbell for additional hours of research and for her dependability, and to S.D.E. Woods for his continuous support.

A special thank you goes to those early photographers who recorded the people, places, and events for more than a century of growth and development of Bartlesville and the surrounding areas.

INTRODUCTION

The impetus for the settlement and development of Bartlesville and the surrounding areas was a horseshoe bend in a river. The Caney River served as a business and transportation center, provided recreation and nourishment, and was the social center of the settlement on its banks. First to settle in the area were the Delaware, Cherokee, and Osage tribes. The Osage had permanent villages along the Verdigris River before 1803. The tribe then relocated to southeastern Kansas before returning to Indian Territory, at Silver Lake, in 1871. Finally, more than 2,000 Osages moved to a reservation in the eastern end of the Cherokee Outlet, approximating Osage County. The Cherokee Nation, which encompassed a large portion of this area, was established in 1839 and was divided into two districts, the larger being Cooweescoowee. Through an arrangement with the United States government, the Cherokee sold land to the Delaware Tribe. In 1867, the Delaware came to occupy lands in the Cherokee Nation through incorporation into the Nation and by purchasing 160 acres of land for each enrollee.

Through marriages to Native Americans, farmers dashed to the grasslands of the Osage Prairie and white settlers entered Indian territory to establish businesses. In 1868, Nelson Carr built a gristmill in the horseshoe bend of the Caney River and, in 1875, sold the mill to another early pioneer, Jacob Bartles, for $1,000. The population of Bartlesville grew to nearly 200 as more and more settlers moved to the area. Bridges, railroads, businesses, and homes were built, and numerous organizations and activities were started in the area. In 1874, the Silver Lake Baptist Church and School operated south of town. By 1897, the Baptist and First Christian churches were built and the town was incorporated. Subscription schools led to public ones, the first permanent one being Garfield School built in 1905. In 1910, the first high school was completed, and in 1917, a combined junior and senior high school was built.

After several reports of a rainbow-like substance appearing on the surface of the river, oil was discovered. On April 15, 1897, the Nellie Johnstone No.1—the first commercial oil well in Oklahoma—blew in as a gusher. The abundance of oil that came with the development of the Bartlesville-Dewey Field in 1904 made Bartlesville an oil boom town almost overnight. Within a few years, nearly 200 oil companies were headquartered in town. Leases in the Osage and around the Bartlesville area led to the rise of companies such as Barnsdall, Getty, Phillips, Sinclair, and Skelly. By 1908, natural gas was fueling three zinc smelters, a brick plant, and a glass factory. Other oil-related businesses also prospered. Armais Arutunoff, inventor of the submersible pump, established REDA Pump headquarters here. Likewise, another pioneer,

H.C. Price, based his pipeline company in the Price Tower, the tallest building designed and built by Frank Lloyd Wright.

Entertainment and sports were a big part of the town's life. Circuses, race tracks, wild west shows, Dewey Round Ups, early movie theaters, and band concerts provided enjoyment. Entertainment also abounded in the outdoors with swimming, fishing, picnics, and hiking. During the mid-1890s, a uniformed baseball team was formed. Music was one of the earliest forms of entertainment as well. Probably the first play presented publicly was in April of 1902, as a benefit for the Cornet Band. The three-act drama, entitled *Diamonds and Hearts*, was presented in the Keeler Building. The first country club, Oak Hill, opened in 1911 with a golf course and swimming pool.

All of the postcards included in this postcard tour of the past are from the archives of the Bartlesville Area History Museum. They are meant to represent the museum's collection and not to serve as a complete history of the area. The museum has hundreds of historical postcards, but with the challenges postcards pose in terms of exhibition, it was decided to publish a postcard book so people would have the opportunity to see more of the collection. Through these postcards, which recorded the people, places, and events of Bartlesville and surrounding communities, the history of our area has been preserved for future generations.

One

SCHOOLS AND CHURCHES

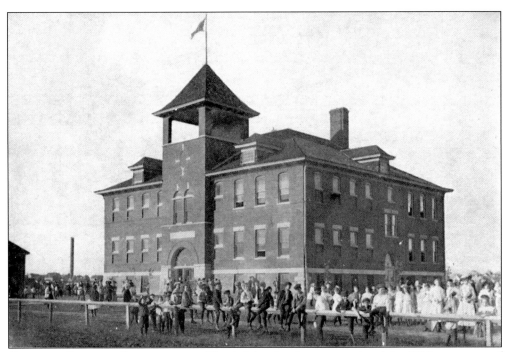

GARFIELD SCHOOL, BARTLESVILLE. The brick school was completed in 1905 at a cost of $17,230, after a revenue from taxes became available. Prior to this, there were four frame buildings on the lot which were used as school buildings. These were built before 1899 with funds from citizen donations.

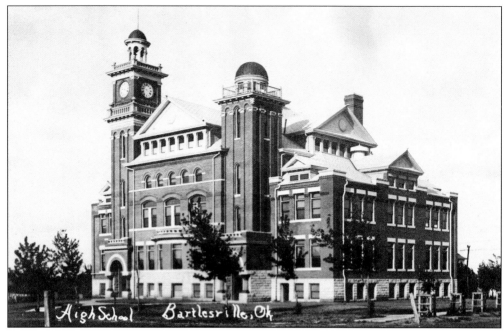

BARTLESVILLE HIGH SCHOOL, C. 1911. Construction was completed on Bartlesville High School, located on Dewey Avenue between Tenth and Eleventh Streets, in the spring of 1910. Graduation exercises were held for 13 graduates in the building, although they had attended Garfield School their senior year. The last class to graduate before the building was vacated was the class of 1926.

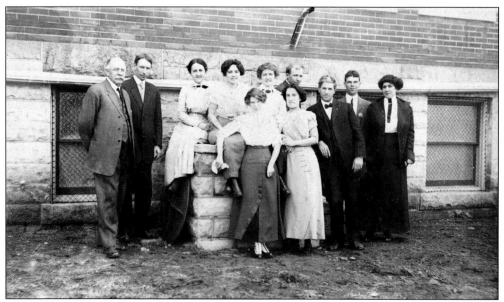

BARTLESVILLE HIGH SCHOOL FACULTY, 1912–13. There were ten teachers, including the principal, who taught the subjects of physics, Latin, English, mathematics, German, commercial studies, music, art, expression, history, and economics.

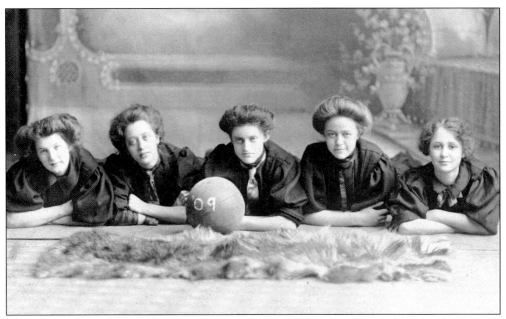

WOMEN'S BASKETBALL TEAM, 1909. In 1908, the Bartlesville High School Women's Basketball team played in the Oklahoma Reds Championship tournament. Members of the team included Mabel Hallman, Ethel Hatch, Leona Wilson, Virginia Somerville, and Grace Evans.

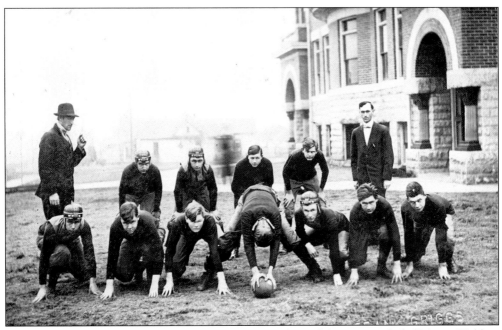

BARTLESVILLE HIGH SCHOOL FOOTBALL TEAM. Members of the team included Morris Webber, Orville Carpenter, Ivan Irwin, Arthur Jastrow, Guard Marvin, S.J. Montgomery, Bernard Elworth, James Hollaman, Kennith Miller, Raymond Locke, J. Hicks, and Mr. Ashbaugh.

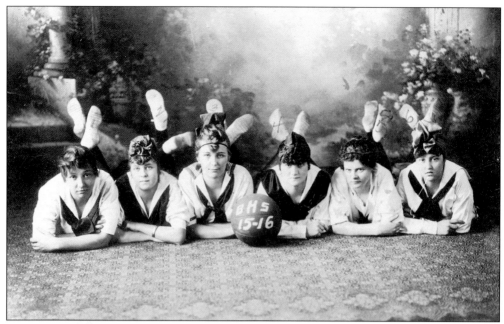

BARTLESVILLE HIGH SCHOOL WOMEN'S BASKETBALL TEAM, 1915–16.

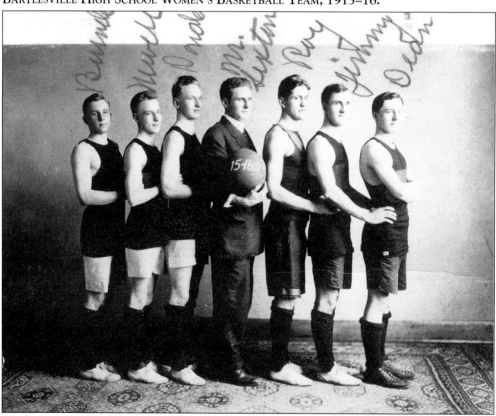

MEN'S BASKETBALL TEAM, 1915–16. Pictured from left to right are, Burnell Graham, Newell Welty, Don Welty, Mr. Sexton, Roy Gray, Jimmy ?, and Dean Schroeder.

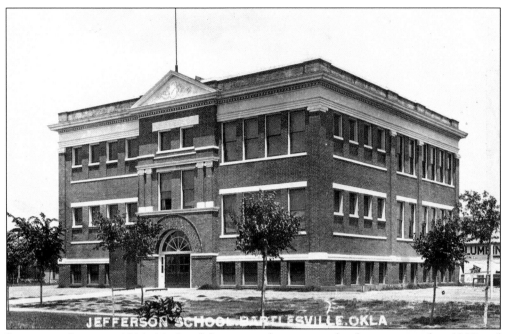

JEFFERSON SCHOOL, 1931–32. Land for a new elementary school was acquired in 1907 and Jefferson Elementary was built in 1909. Additions to the structure were added in 1924, 1929, and a final addition in 1948. The school was closed in 1985.

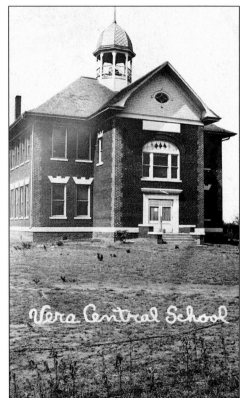

VERA CENTRAL SCHOOL, VERA, OK, 1910. This was the third school built in Vera. A post office was established in Vera in 1899, and in 1904, the town was incorporated with Hugh Watson as the first mayor and as a teacher in the first school. In 1928–29, a substantial school was built at a cost of around $30,000 to serve ranch and farm families over a wide area.

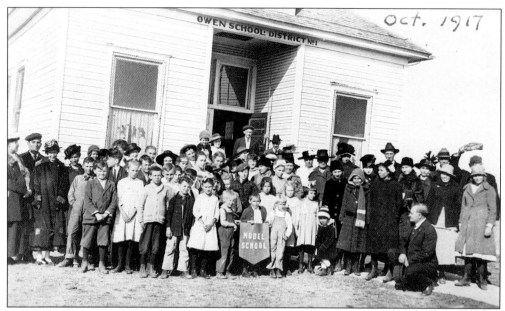

OWEN SCHOOL, OCTOBER 1917. Teachers in 1917 were Annabell Roberts and Helen Moran. They, along with students and parents, celebrate the Model School award. The school was established in December 1907. The school and the Robert L. Owen Ranch were located in the northwestern part of the Cherokee Nation, near the Kansas border. Owen was one of Oklahoma's first United States Senators from 1907 to 1925.

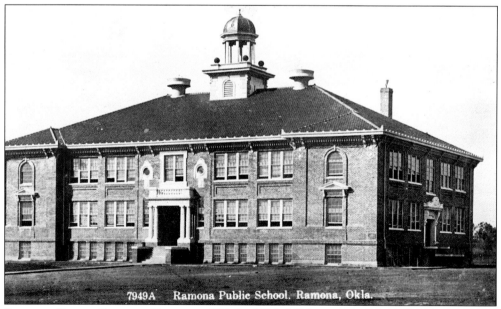

RAMONA PUBLIC SCHOOL, RAMONA, OK. In 1900, $200 was raised, by selling box suppers, to construct a small school building to replace a subscription school. In 1905, the school had five teachers, one of whom was employed by the Cherokee National Council. Educational opportunities were financed to a large extent by tax revenues from oil stored in the tank farm north of town. A brick building was erected in 1909.

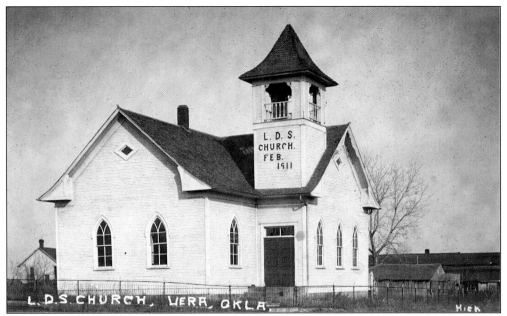

REORGANIZED CHURCH OF JESUS CHRIST OF LATTER DAY SAINTS, VERA, OK, 1911. The RLDS was organized in 1830 in New York. The headquarters is located in Independence, Missouri.

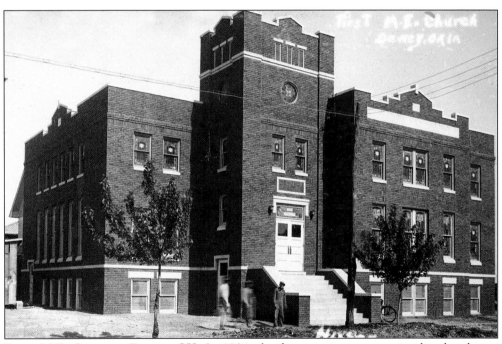

FIRST M.E. CHURCH, DEWEY, OK. In 1904, the first meeting to organize the church was held in Bartles Hall in the Old Bartles building at Eighth and Delaware. The first minister was Reverend Trewyn, who was employed at Jake Bartles' store. Meetings were held in the hall until 1907 when the first frame building was completed. Another structure was dedicated at Seventh and Delaware in 1910.

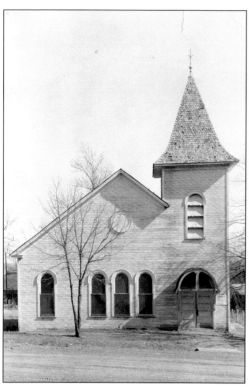

FRIENDS CHURCH, RAMONA, OK. The Friends, or Quakers, historically concerned with missionary work among the Native Americans, established Hillside Mission on Bird Creek in the late 1880s. Reverend and Mrs. J.A. Griffiths moved to the newly incorporated town of Ramona in 1902 to set up the school system there. They also established a Quaker Mission in Ramona, which became the town's first church.

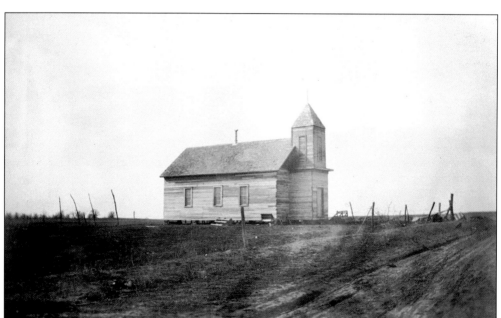

GLEN OAK METHODIST CHURCH, NOWATA COUNTY. Nowata and Washington Counties shared the community of Glenoak, located eight miles east of Bartlesville. A post office was opened in February 1906 and remained in service until December 1932. An early school in the neighborhood was also called Glenoak. The Glenoak Oil Field was located about two miles south of the town in 1911.

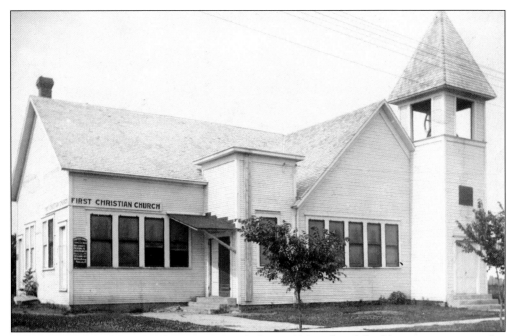

First Christian Church, Bartlesville. In June 1900, a church building was constructed at the corner of Third and Johnstone. Mrs. T.A. Stewart, wife of one of Bartlesville's first doctors and first mayor, was a leader in this congregation. William Ward became pastor in 1904, and Elder R.E. Rosenstein began his ministry in April 1905. A new church was built on the corner of Sixth and Osage in 1910.

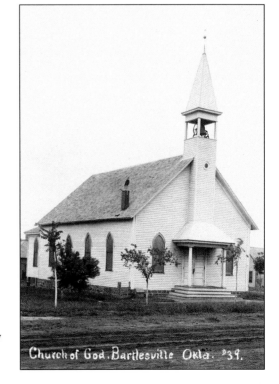

Church of God, Bartlesville, OK, 1939. The Church of God was organized in 1902 by Reverend P.L. French, a Native American minister from Colorado. The church building at Eighth Street and Dewey Avenue was dedicated June 5, 1902, by Reverend S.G. Yahn of Pennsylvania.

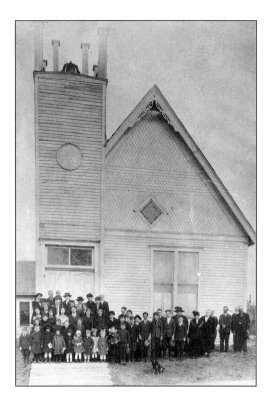

First United Brethren Church, Bartlesville, OK, 1940. Located at 708 E. Third, the pastor was Reverend Paul E. Caskey and in 1942, Reverend A.G. Todd is listed as pastor. A 1921 *Morning Examiner* lists services held at the church: Sabbath school—9:45 a.m., Morning service—11 a.m., and Evening service—8 p.m. Reverend I.M. Hoagwood was pastor at this time.

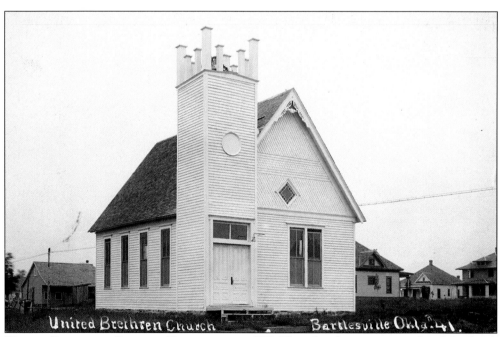

United Brethren Church, Bartlesville, OK. This church was organized on March 26, 1909, by Rev. Ella L. Tharp. The congregation moved its church building to Third Street and Seneca. In 1924, a brick building was constructed, and a brick parsonage was added in 1954.

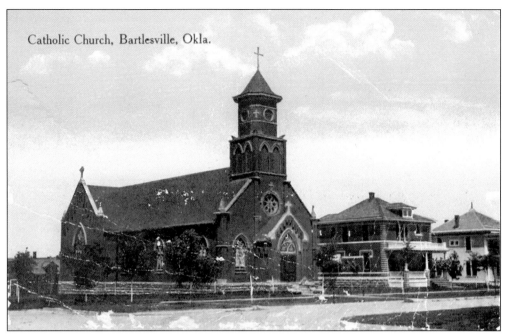

CATHOLIC CHURCH, BARTLESVILLE, OK. In 1901, Father Edward, a Jesuit priest, began a mission, probably celebrating Mass above the Govreau Harness Store on Second Street. On January 22, 1905, a red brick church on the corner of Eighth and Johnstone was dedicated as a mission to the Pawhuska Catholic Church. The mission became St. John parish in 1906, with Father John Van den Hende as resident pastor.

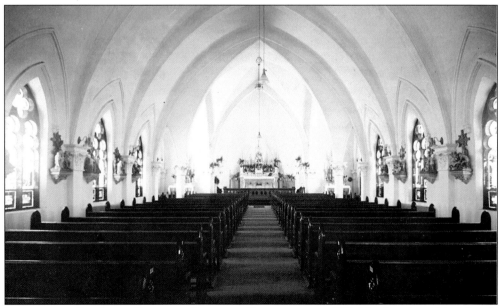

INTERIOR OF ST. JOHN CATHOLIC CHURCH, BARTLESVILLE, OK. The interior of the church reflects the beauty of the stained-glass windows, which were imported from France. The faceted windows are interpretations of traditional Christian subjects. They are necessarily broad in treatment because of the nature of the thick glass in heavy matrix.

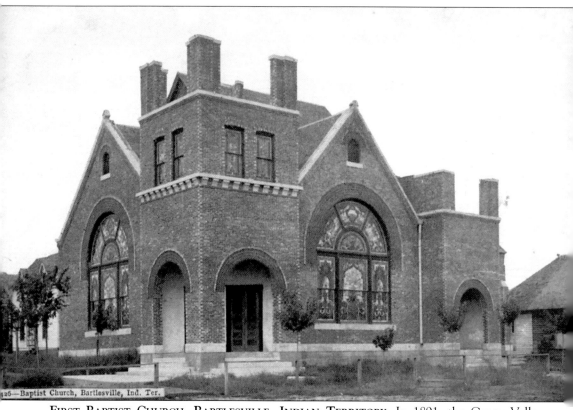

FIRST BAPTIST CHURCH, BARTLESVILLE, INDIAN TERRITORY. In 1891, the Caney Valley Baptist Church was organized with 33 charter members, many joining from the Delaware Baptist Church at Alluwe and from the Silver Lake Baptist Mission. Reverend George H. Goodwin was the first pastor. In 1897, the church meeting site was moved to a new frame church at the southwest corner of Fourth and Cherokee. The building was destroyed by fire on September 19, 1905, at a loss of $2,000. Records later recovered indicate that the name of the church changed from the Caney Valley Baptist Church to the First Baptist Church in 1899. A new church was constructed on the same site and dedicated in September 1906.

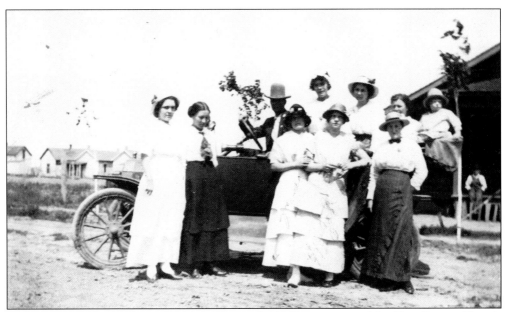

VIRGINIA AVENUE BAPTIST CHURCH PICNIC. In 1909, a mission of the First Baptist Church was built at Third and Virginia. Frank Overlees was the leader, devoting both time and financial support. The mission was organized into a church in 1911 with Reverend J.B. Smith as pastor. In 1928, a tabernacle was erected, and in 1929, the original frame building was replaced with a red brick one.

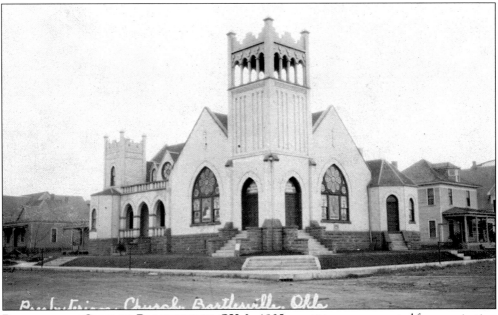

PRESBYTERIAN CHURCH, BARTLESVILLE, OK. In 1905, a petition was presented for organization of a Presbyterian church in Bartlesville. There were 29 charter members with Reverend Ralph J. Lamb as the organizing minister. In February 1906, a lot at the corner of Fifth and Dewey was purchased for $2,500 as the building site. Church services and other meetings were held here until 1907 when the first church building was completed.

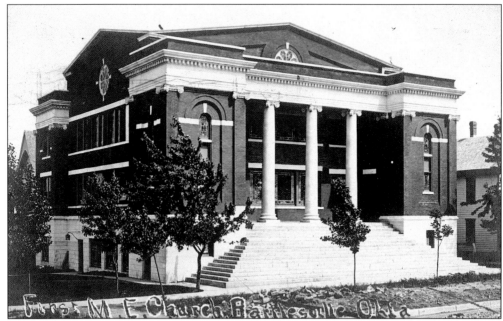

FIRST M.E. CHURCH, BARTLESVILLE, OK. The Methodist Episcopal Church South was organized in 1895 with Reverend Byers as the first minister. Another branch of the Methodist Church—the Methodist Episcopal Church—was formally organized in 1901 with Reverend John Wesley Bowen as minister. Reverend Milo N. Powers was appointed to the Bartlesville ministry in 1904, and through his efforts, the two Methodist churches were consolidated in 1905.

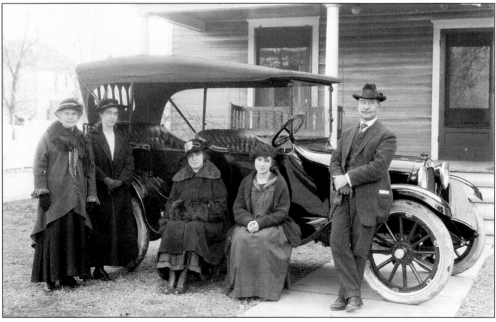

THE REVEREND JOSEPH E. COE FAMILY. Reverend Coe was pastor of the Methodist Episcopal Church from 1914 to 1920. He and his wife Edna resided with their family at 111 E. Fifth Street.

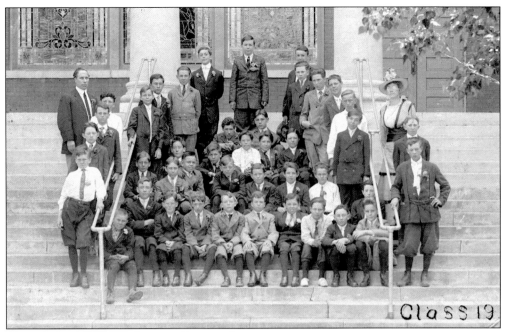
METHODIST EPISCOPAL SUNDAY SCHOOL CLASS.

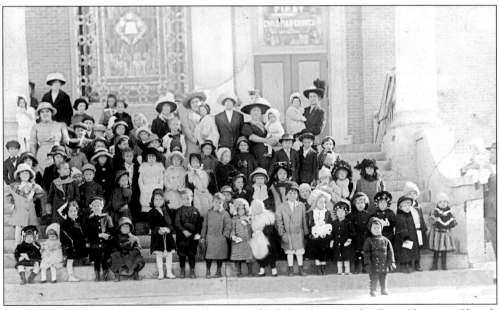
FIRST CHRISTIAN CHURCH SUNDAY SCHOOL. On July 18, 1897, the First Christian Church was organized and the first meeting was held in Johnstone Park with Reverend J.R. Charlton as the first pastor. The new church was dedicated on January 7, 1900, with an indebtedness of $400.

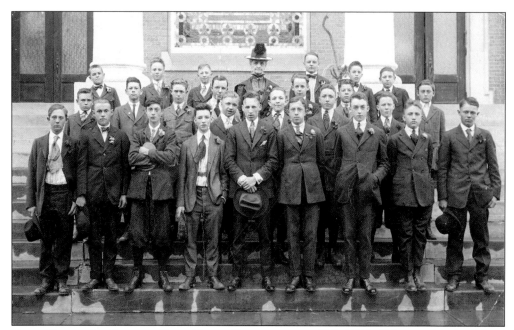

FIRST CHRISTIAN CHURCH BOYS CLASS, BARTLESVILLE, OK, 1919. Taken on Mother's Day, a teacher, Mrs. Leslie Combs, is surrounded by high school boys. Included are: Harrold Holt, Louis Plunkett, Adam Johstone, Ernie Holt, Hulbert Holt, Robert Dufford, Wilbur Hund, Jack Walker, Terrance Lobaugh, Malcom Welty, L.E. Phillips Jr., Alfred Garrison, Jay Lynn Overlees, Louis Hall, Laurence Darnell, Mervyn Hold, Howard Taylor, Phil Phillips, James Thornbury, George McDonald, Cooley Vincent, and Raymond Darnell.

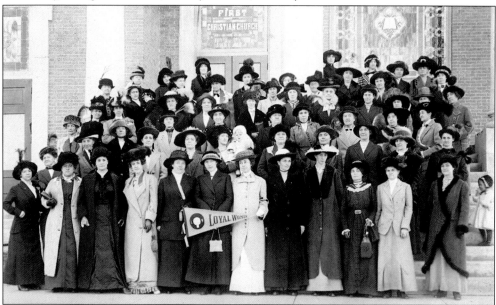

LOYAL WOMEN, BARTLESVILLE, OK, 1913. This group of women met as a Sunday school class in the First Christian Church for a number of years. In February 1908, a lot at Sixth Street and Osage Avenue was secured and a basement built. The congregation worshipped here for about three years until work on the building was completed in 1911.

FIRST CHRISTIAN CHURCH SUNDAY SCHOOL CLASS, BARTLESVILLE, OK, 1913. In January 1900, a church building was constructed and dedicated at the corner of Third and Johnstone. Later, the same building was moved to the corner of Third and Osage. This building was then sold to the United Brethren Church who moved it to Third and Seneca.

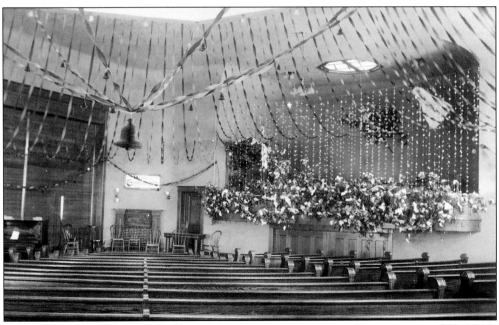

INTERIOR OF FIRST CHRISTIAN CHURCH ON CHRISTMAS NIGHT, BARTLESVILLE, OK, 1913. A 1913 *Daily Enterprise* article reported that Reverend Roger Fife resigned as pastor of the First Christian Church. C.H. Hulme became minister of the church until 1923.

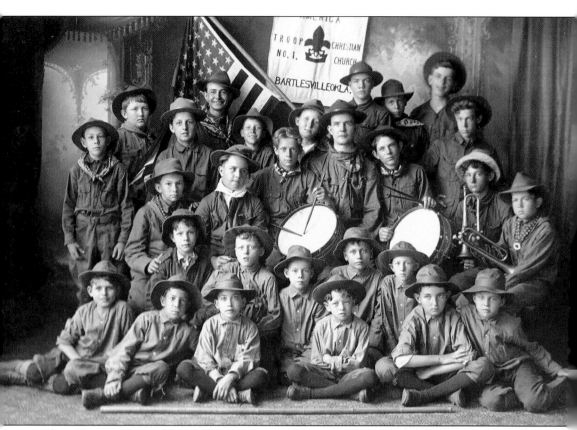

BOY SCOUT TROOP NO. 1, BARTLESVILLE, OK, 1912. Possibly the second official troop in the United States was formed in Bartlesville under the auspices of the First Christian Church. Reverend Charles Hulme, pastor, was leader. Members of the first troop included Ralph Bagley, Howard Boggs (the first Eagle Scout in Bartlesville), Jim Boggs, Frank Breene, Maurice Breene, Royce Calkins, Harold Duck, Elmer Fenton, Roy Gray, Harry Hicks, John Jackson, Guard Marvin, Jack McFadden, J. Frank Rice, Hayden Snyder, Mortimer Stilwell, Sherwell Weber, and Mike Wren.

Two

ENTERTAINMENT

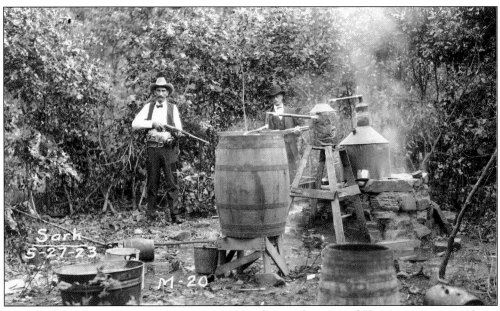

STILL CAPTURED BY SPECIAL STATE POLICE IN OSAGE COUNTY, OK, MAY 27, 1923. Harve Parrick and John Creed, state liquor officers, stand beside a still they discovered on Candy Creek. The illegal liquor traffic was a major problem for local lawmen as bootleggers catered to the great influx of people hurrying to the latest oil strike.

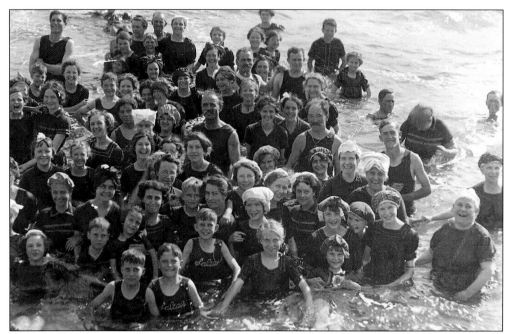

SWIMMING IN THE CANEY RIVER. By 1915, a swimming beach was constructed above the natural rock dam across the Caney River by raising the dam with concrete. Bathhouses were built and soon became popular gathering places. Sometimes 200 people were splashing and swimming in the river at the same time. The oil floating on the river was removed with a skimmer so people could swim.

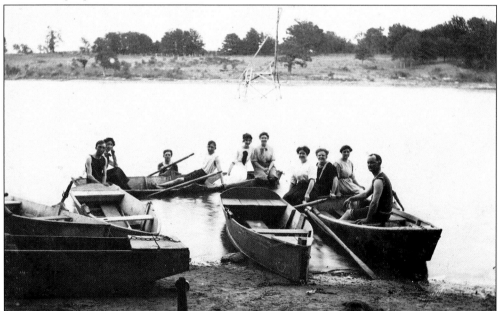

BOATING AT SILVER LAKE, BARTLESVILLE, OK. Silver Lake became a center of religious, social, and cultural life among the Delaware, Cherokee, and white settlers in the area. It was a recreation and entertainment site until the late 1920s. Picnics, bathing parties, sporting events, and even baptisms were held here.

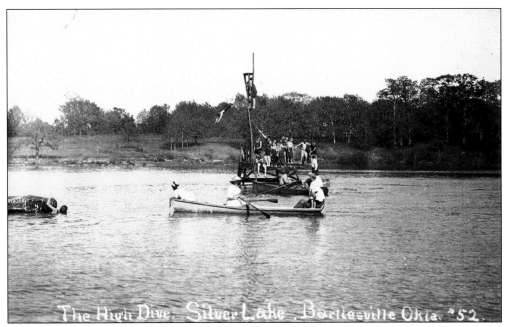

THE HIGH DIVE AT SILVER LAKE, BARTLESVILLE, OK. One of the few natural lakes in the Caney River watershed, Silver Lake attracted many early Delaware settlers. Trading posts, churches, schools, and private homes dotted its shoreline. It was here that John Sarcoxie built his home—a two-story, stone and wood structure, with porticoes on three sides.

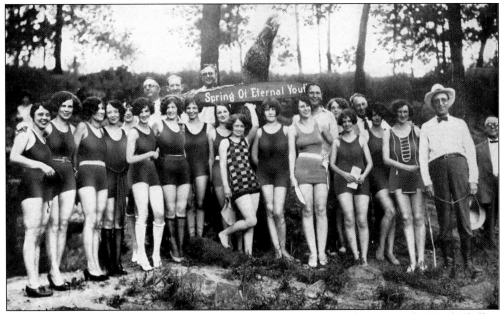

BEAUTY CONTESTANTS AND JUDGES, JULY 24, 1926. As a way to boost morale, Frank Phillips invited employees to his ranch for a "jump in the lake." More than 700 employees attended the festivities held around Clyde Lake. Beauty contests were often held in conjunction with the employee picnics. Contestants were Phillips Petroleum Company employees; judges were usually Phillips' executives.

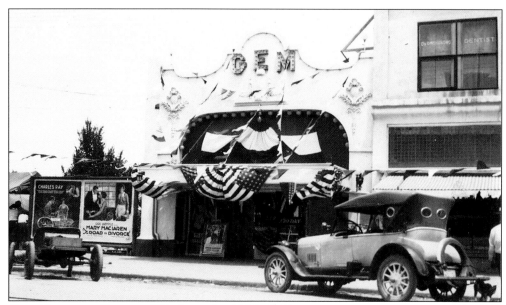

GEM THEATER, DEWEY, OK, JULY 5, 1920. Public entertainment opportunities in the area expanded steadily as the towns grew. From live entertainment, updates were made to accommodate the showing of motion pictures. Booths were installed in balconies and "jumping tintypes" were shown in conjunction with vaudeville acts. The early movies were silent. Pictures were rented by the theater operator for $1 a reel and were shipped from town to town.

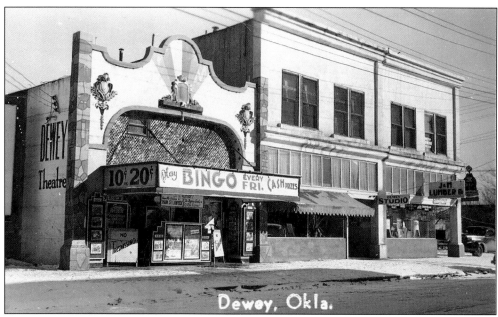

DEWEY THEATRE, DEWEY, OK. Many theaters in the 1930s and '40s had special attractions such as bingo and cash drawings to lure patrons to the establishments. The first owner of the Dewey was Earle M. Freiburger and the last owner was Walter Willis Bell Sr. The theater closed in the late 1970s.

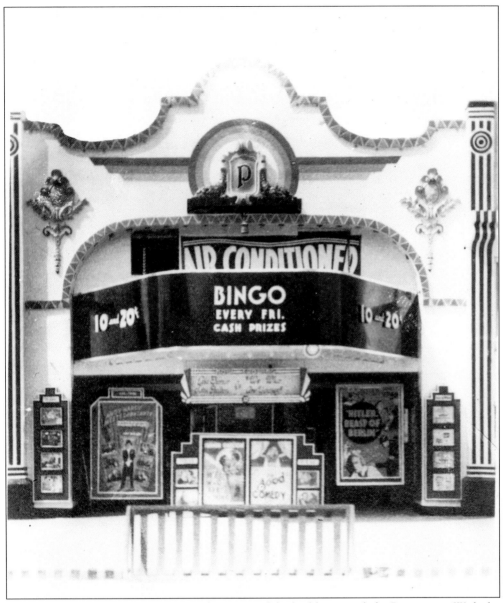

THEATER IN DEWEY, OK. The "P" in the center of the building stands for Paramount. With the arrival of air-conditioning, many businesses advertised the fact that they had air-conditioned buildings to attract patrons.

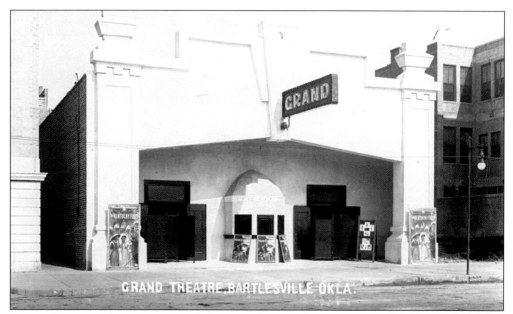

GRAND THEATER, BARTLESVILLE, OK. Located at 325 Dewey Avenue, the theater was known as the Grand from 1913 until 1917 when the name changed to Lyric. A 1928 newspaper story related the fact that the Lyric was installing Vitatone and Movietone equipment for talking pictures at a cost of $15,000.

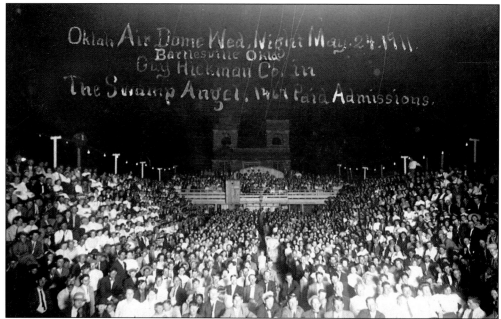

OKLAH AIR DOME, BARTLESVILLE, OK, MAY 24, 1911. The first open-air theater opened May 3, 1908, with John "Dad" Flynn as manager; J.L. Overlees was the owner. The theater was located at the northeast corner of Fourth and Dewey. On this Wednesday night, the Guy Hickman Company was cast in "The Swamp Angel." There were 1,467 paid admissions. Regularly, more than 1,500 people crowded in to see the stage plays.

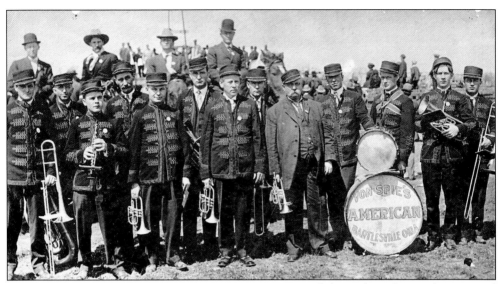

VON SPIES BAND, BARTLESVILLE, OK. Music was one of the earliest forms of year-round entertainment in the pioneer communities.

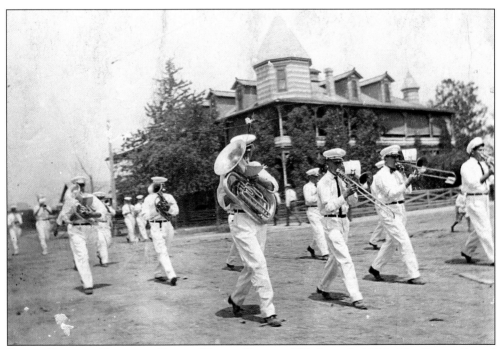

DEWEY BAND IN FRONT OF DEWEY HOTEL, DEWEY, OK, JULY 4, 1911. The Dewey Round Up, held annually on the holiday weekend, provided entertainment in addition to the bronc busting and calf-roping contests. On the morning of the 4th, there was a band concert, speeches, and at noon, a barbecue dinner was provided. There were 8,000 people in attendance that day, and 12,000 during the entire weekend.

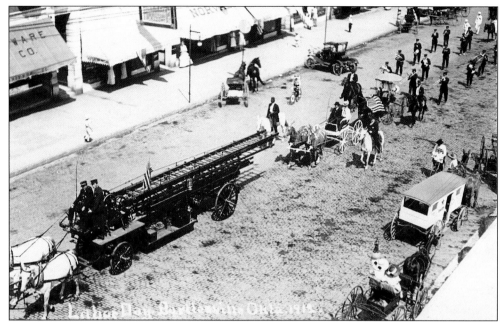

LABOR DAY PARADE, BARTLESVILLE, OK, 1913. Bartlesville's horse-drawn fire engine participated in the parade. L. Lamont Higbee was chief of the fire department.

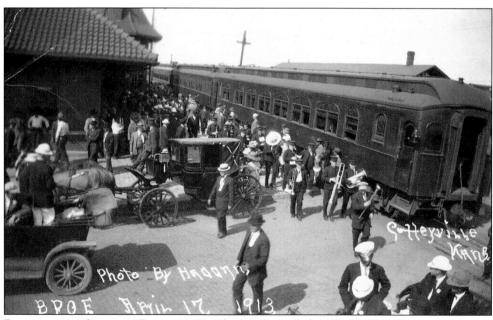

BARTLESVILLE CONCERT BAND, 1913. The band traveled to Coffeyville, Kansas, to play for the opening of the new Elks Home.

FREIBURGER'S ORCHESTRA, BARTLESVILLE, OK. Earl Freiburger was the manager.

JOHNSTONE PARK, BARTLESVILLE, OK. On Sunday afternoons, band concerts were held in the Shelter House in Johnstone Park. The Shelter House was built in 1916–17.

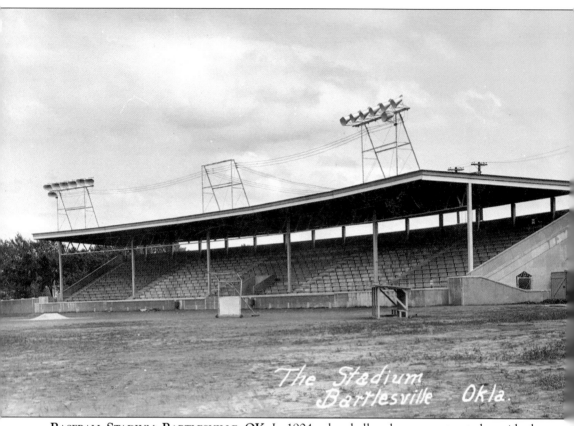

BASEBALL STADIUM, BARTLESVILLE, OK. In 1904, a baseball park was constructed outside the city limits at the south end of Johnstone near Eleventh. The grandstand was roofed, and seated 500 people. By February 1905, the first baseball park was abandoned and a deal was closed for grounds a block south of the 1904 diamond. The second park was also abandoned within a year as the building of new homes advanced rapidly in that direction. In 1906, William Johnstone donated to the city a lot on Dewey Avenue just north of the city limits for a baseball park.

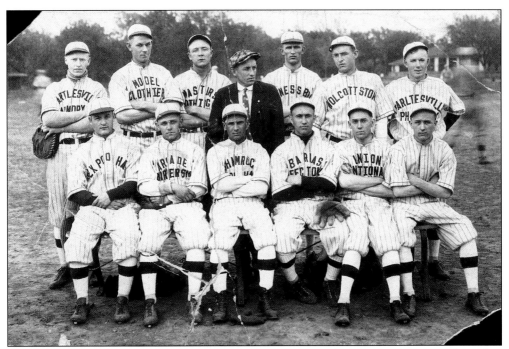

MERCHANTS BASEBALL TEAM, BARTLESVILLE, OK, 1914. This amateur team was formed in 1913 with players Chesnut, Rittesbarker, Keetling, Cotton Estus, Hampton, Peterson, Scrivins, Hooper, Ferd Estus, Burns, and Towers.

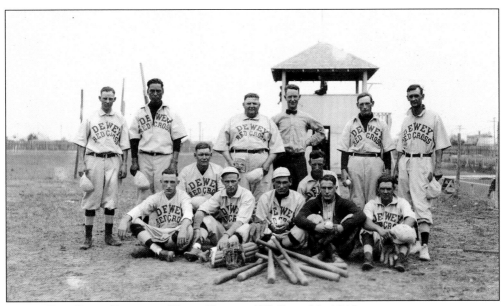

DEWEY RED CROSS BASEBALL TEAM, DEWEY, OK, JULY 28, 1918.

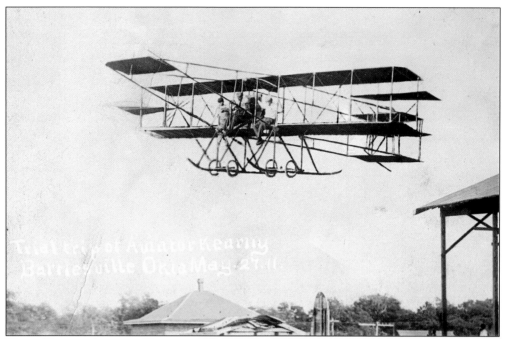

TRIAL TRIP OF AVIATOR KEARNEY, BARTLESVILLE, OK, MAY 27, 1911. Under the auspices of the Commercial Club, 5,000 visitors to Bartlesville were to attend an aeroplane exhibition, race, and cross-country flight. Unfortunately, the original event was postponed due to a wreck.

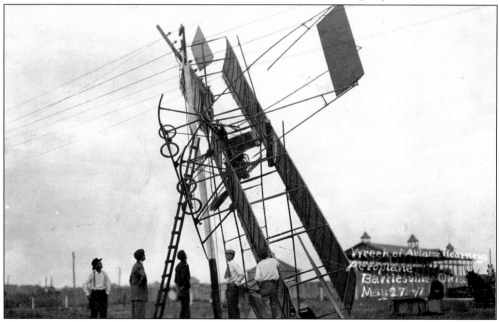

AEROPLANE WRECK, BARTLESVILLE, OK, MAY 27, 1911. During a trial flight by Horace F. Kearney to check the machine for an afternoon exhibition, a sudden gust of wind veered the machine toward the ground, striking telegraph wires and throwing Kearney from his seat. He landed on the live wires and his body formed a short circuit that blew out the fuses in the Prairie Oil Company's power house.

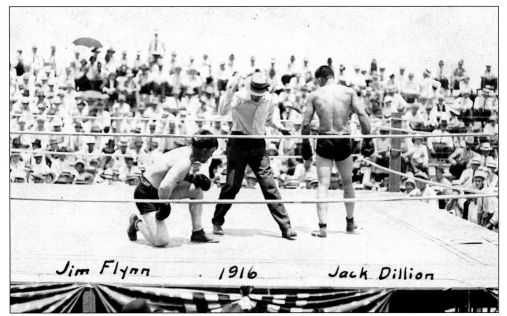

FLYNN-DILLION FIGHT, DEWEY, OK, JULY 4, 1916. This prize fight attracted thousands of fans. Jim Flynn was from Excelsior Springs, Missouri, and Jack Dillion was from Indianapolis, Indiana. Flynn was knocked down by Dillion in the fourth round. It is said that Flynn refused to get up saying it was "too damned hot to fight."

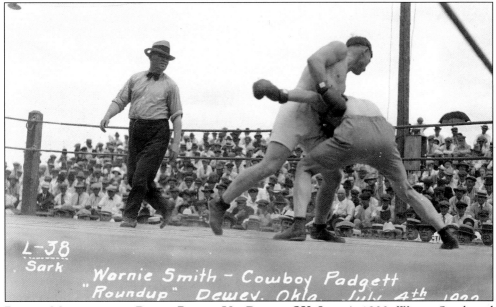

BOXING MATCH AT THE DEWEY ROUND UP, DEWEY, OK, JULY 4, 1922. Warnie Smith and Cowboy Padgett had a 12-round fight with the decision going to Padget in the sixth round on a foul. "Rube" Ferns was the referee.

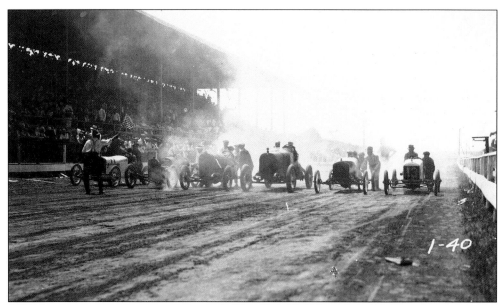
AUTOMOBILE RACES, DEWEY, OK, 1920. Drivers are waiting for the signal to begin the race, one of the many events at the Dewey Round Up on July 5.

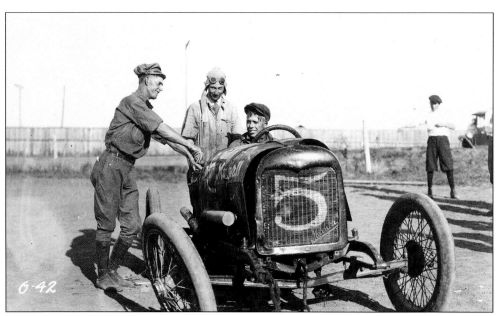
WRECKED IN RACE, DEWEY, OK, SEPTEMBER 28, 1918. E.D. Lusk, A.J. Reed, and C.F. Jackson inspect the wrecked Maxwell.

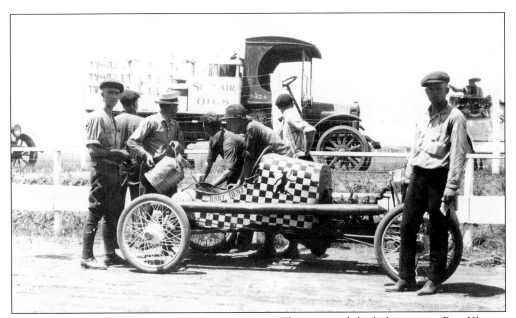

"BABY BENZ" FORD, DEWEY, OK, JULY 5, 1920. This automobile, belonging to Roy Klewer, was driven in the races held at the annual Dewey Round Up.

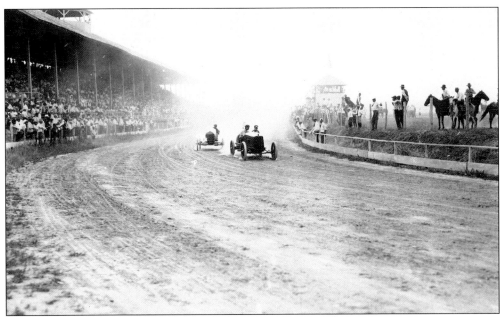

SAXTON LEADING FORD IN AUTO RACE, DEWEY, OK, JULY 4, 1918.

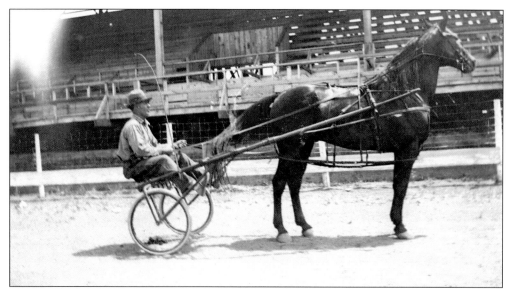

TROTTING RACES AT THE DEWEY FAIRGROUNDS, DEWEY, OK, 1917. In 1908 the Driving Park Association, which promoted the racing of trotting horses hitched to two-wheel carts, was organized. Shown here is *Hi-tak-a-wah*, which means "man looking at the sun," a sorrel stallion owned by a Kingfisher, Oklahoma man.

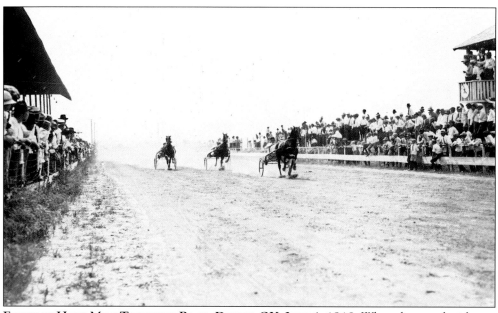

FINISH OF HALF-MILE TROTTING RACE, DEWEY, OK, JULY 4, 1918. When the state legislature created county free fairs in 1915, Joe Bartles and his mother, Nannie, donated 40 acres of land joining Dewey on the north side for a Washington County Fairgrounds. A 7,000-seat grandstand was built along with a one-half mile racetrack and several exhibit buildings.

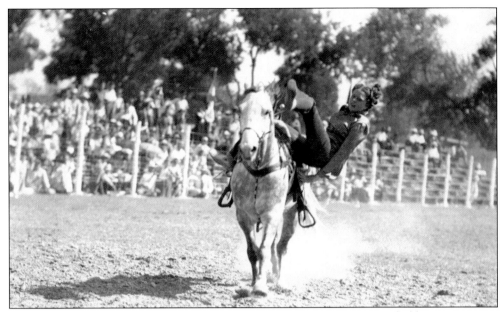

TRICK RIDING. During World War I, all of the performances but one were held to raise money for the Bartlesville and Dewey chapters of the Red Cross. After the war, the Round Up was renewed and quickly grew into a world-famous rodeo. It was one of the three largest rodeos in the world. The last Round Up was held in 1948.

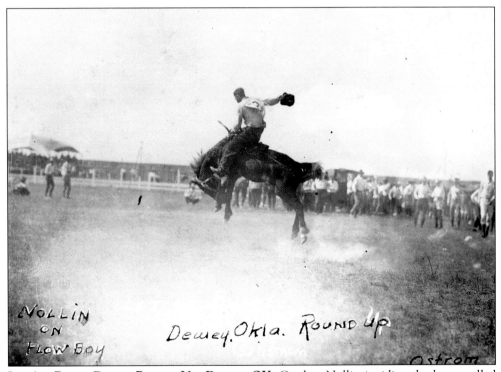

LET 'ER BUCK, DEWEY ROUND UP, DEWEY, OK. Cowboy Nollin is riding the horse called Plowboy.

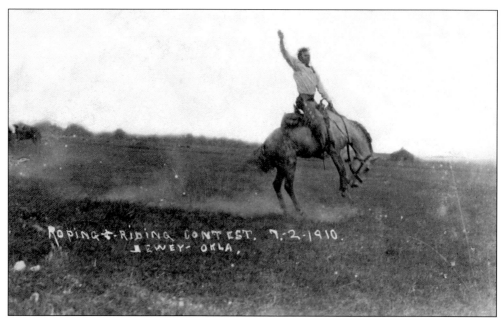

ROPING & RIDING CONTEST, DEWEY, OK, JULY 2, 1910. In 1908, Joe Bartles organized some cowboys from nearby ranches to entertain his father's friends at their annual reunion. The cowboys put on demonstrations of roping, riding, and other stunts behind the Dewey Hotel. Many local residents also attended, and the event eventually attracted such crowds that it became a traditional Fourth of July event known as the Dewey Round Up.

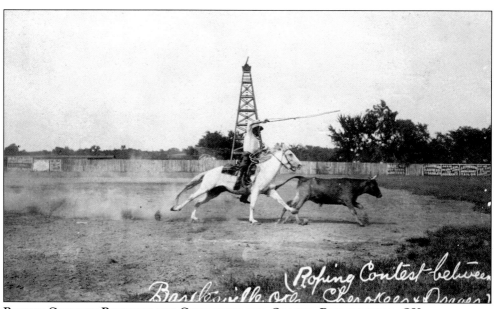

ROPING CONTEST BETWEEN THE CHEROKEES AND OSAGES, BARTLESVILLE, OK.

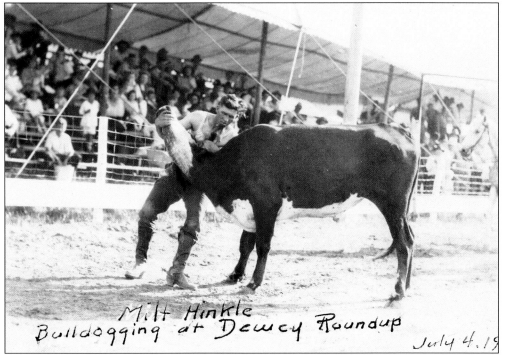

MILT HINKLE BULLDOGGING A STEER, DEWEY ROUND UP, DEWEY, OK, JULY 4, 1912.

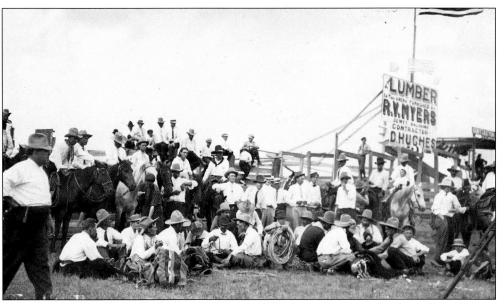

COWBOYS AT THE ROPING CONTEST, DEWEY, OK, JULY 4, 1912. Cowboys from all over the world came to Dewey to perform at the Round Up. One of Washington County's world champion ropers, Henry Grammer, was a frequent performer at the annual events.

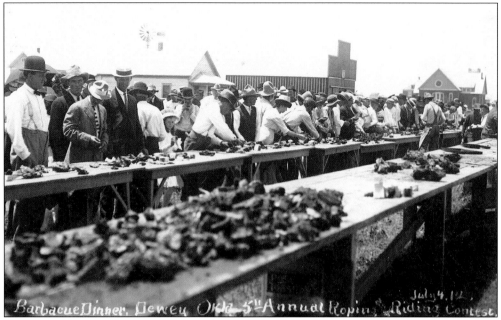

Barbecue Dinner, Dewey, OK, July 4, 1912. Cowboys prepare the feast held in conjunction with the 5th annual roping and riding contest during the Dewey Round Up. The meat was cooked over pits, then the cooks turned the meat with pitchforks and served it on the large log tables.

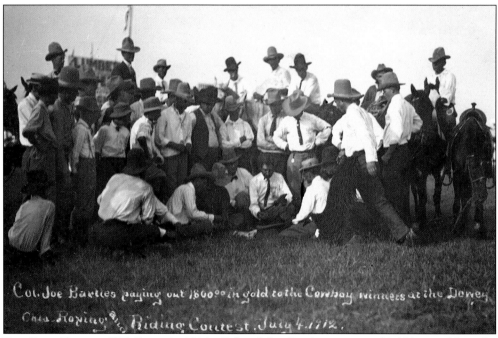

Pay Day, Dewey, OK, July 4, 1912. Colonel Joe Bartles pays out $1,800 in gold to the cowboy winners of the roping and riding contest. Bartles always paid off in gold, with total prize money running as high as $2,000.

Three

OIL AND THE OSAGE

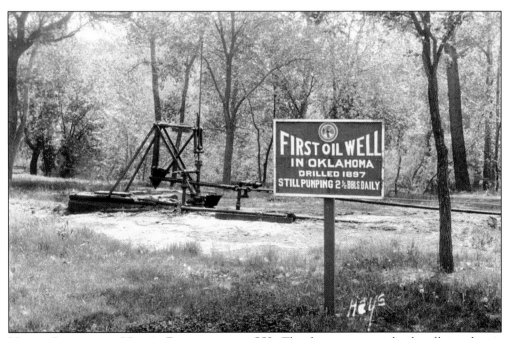

NELLIE JOHNSTONE NO. 1, BARTLESVILLE, OK. The first commercial oil well in what is now Oklahoma was drilled in the Cherokee Nation in 1897. At 1,303 feet, drillers hit an oil-producing sand—the Bartlesville sand. The well itself was named for Nellie Johnstone, daughter of William Johnstone. The well produced more than 100,000 barrels of oil in its lifetime.

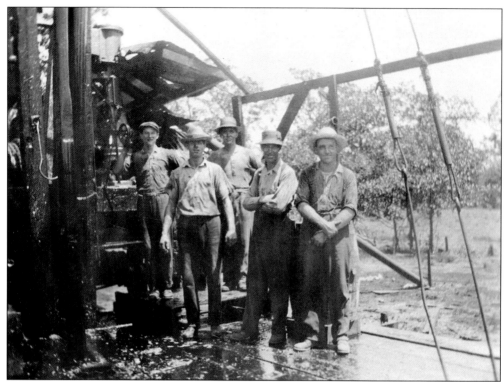

DRILLERS AT WELL. Drilling in Indian Territory started in the 1880s after oil men tapped into the mid-continent region in Kansas. Oil deposits were well known in the area, but there were difficulties with land leasing and oil development by federal officials and the common tribal ownership of the land. Nonetheless, by 1904 more than 100 wells had been drilled around Bartlesville.

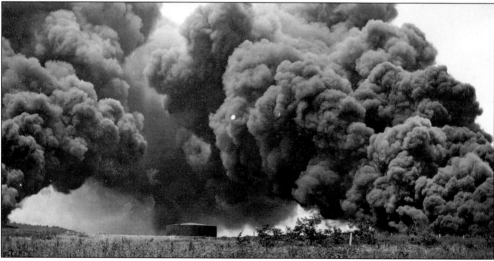

OIL FIELD FIRE, AUGUST 1922. One tank was struck by lightning at 5:30 a.m. and the other about 15 minutes later. They were of 35,000 bbl. capacity and both were full of crude oil. The tanks were located about four miles from town and happened to be on the edge of a tank farm so no other tanks caught fire. The loss was estimated at about a quarter of a million dollars.

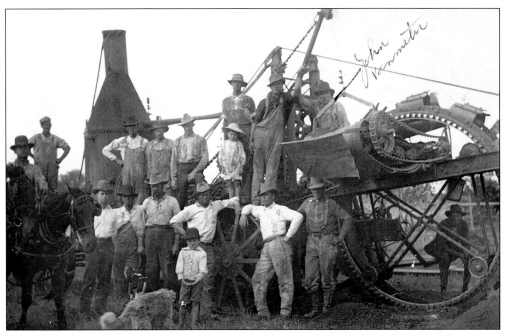

OIL FIELD TEAM. The lure of black gold brought thousands of oil men, financiers, speculators, businessmen, bankers, roustabouts, and adventurers to the area. They came by foot, by horse, in wagons, and on trains. Bartlesville, Dewey, and other growing settlements along the railroad provided depots for oil people, oil fields, and oil camps.

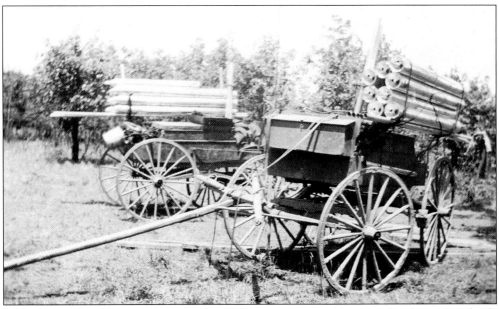

WAGONS OF TORPEDOES. Nitroglycerin torpedoes were placed in oil wells, then a "go-devil" was dropped to force out the oil, along with any sand, water, and so forth in the area. Hauling the nitroglycerin was a very dangerous job. Even the slightest bump could cause an explosion. In fact, hauling nitroglycerin within the city limits of Bartlesville was outlawed when one too many accidents caused serious damage.

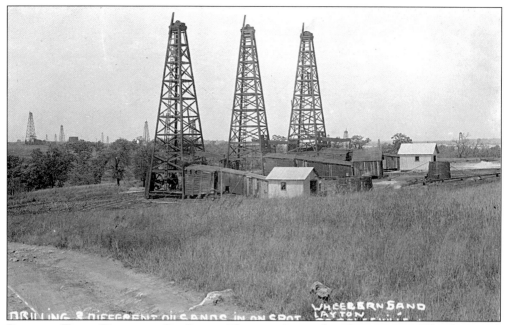

DRILLING THREE DIFFERENT OIL SANDS. Three sands were found in one spot: Wheelern sand, Layton sand, and Bartlesville sand. With the drilling of the Nellie Johnstone No. 1, Layton Sand was found at 975–987 feet and Bartlesville Sand at 1,303 feet.

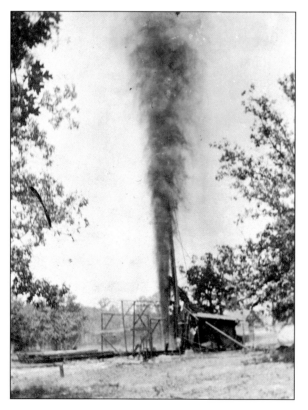

A GUSHER! Some early oil wells flowed as much as 1,000 barrels of crude daily. Average production in 1906 was 73.2 barrels. By 1914, there were 4,816 producing wells, but the average daily production had dropped to 10.4 barrels. Drilling continues throughout Washington County's history. By 1994, wells were producing 462,852 barrels of crude, 122,313 barrels of casinghead gas, and 352,847,000 cubic feet of natural gas annually.

OIL RIG WORKERS, 1915. Vincent Cheffler and Albert Culp are pictured at well #5, Lot #286 on July 28.

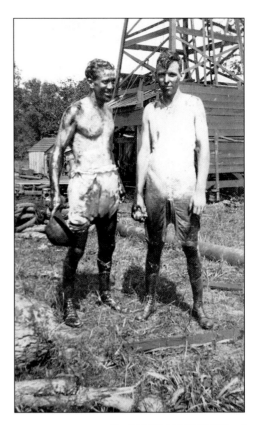

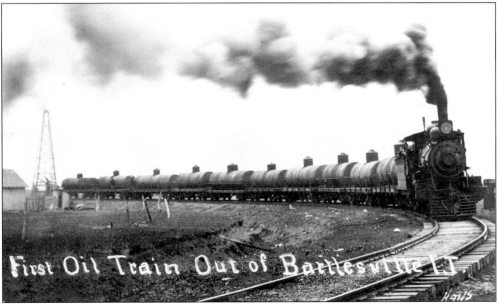

FIRST OIL TRAIN OUT OF BARTLESVILLE, OK. The greatest hindrance to the early oil development was an absence of transportation facilities to move the crude oil to refineries. This problem was alleviated in May of 1900 when the Atchison, Topeka and Santa Fe railroad hauled the first train of oil tank cars from Bartlesville to the refinery in Neodesha, Kansas.

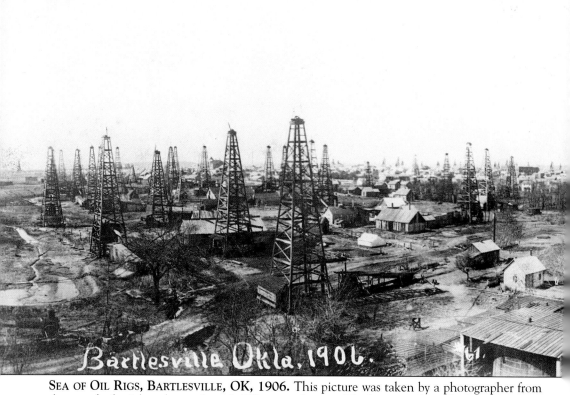

SEA OF OIL RIGS, BARTLESVILLE, OK, 1906. This picture was taken by a photographer from the top of a derrick at the north end of Shawnee Avenue. The house in the right foreground was the early home of George B. Keeler. Town lot drilling was carried on throughout Bartlesville until it was outlawed by a city ordinance in 1909. The city was noisy and busy with derrick construction. The streets were full of dust or mud, depending on the weather.

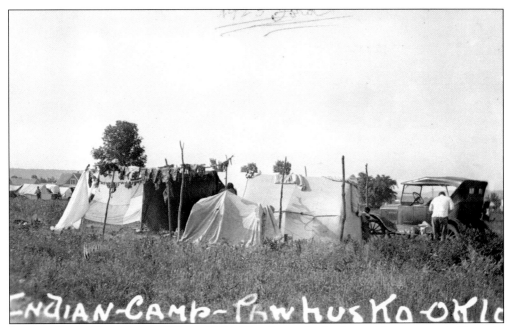

INDIAN CAMP, PAWHUSKA, OK, C. 1922. The Osages had substantial permanent villages in future Washington County along the Verdigris River before the Louisiana Purchase of 1803. The tribe relocated to a reservation in Southeastern Kansas by terms of the Treaty of 1825. The Osages then returned to Indian Territory in 1871, when they were mistakenly settled south of Bartlesville at Silver Lake.

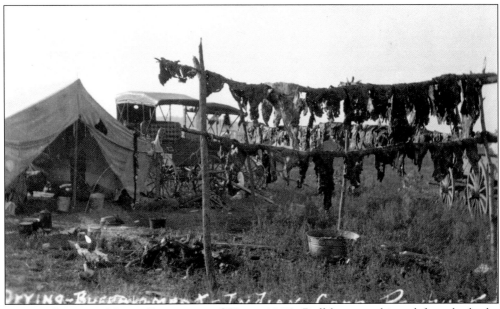

DRYING BUFFALO MEAT, PAWHUSKA, OK, C. 1915. Buffalo were skinned from both the underside and the backside, then the meat was taken to camp for preserving. Bundles of meat were stripped lengthwise and hung from racks to dry. After drying, the meat was packed in parfleches—rawhide storage bags.

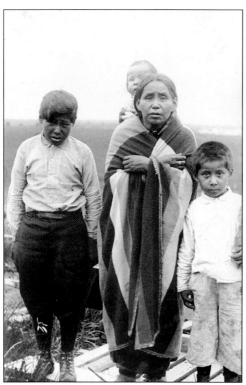

OSAGE MOTHER AND CHILDREN. In an Osage family, the parents were primarily responsible for the education of their children. The mother taught both boys and girls for the first few years of their lives; then, at about the age of five or six, the father took over the training of the boys while the girls remained with their mother.

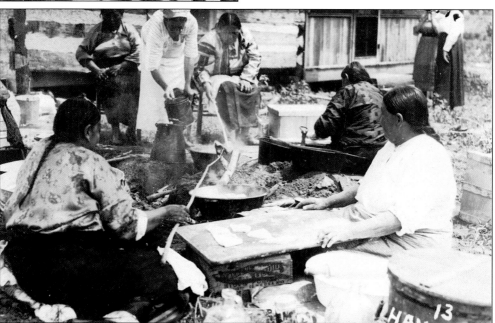

OSAGE WOMEN WORKING. Traditionally, work in the fields was performed by women or was accomplished under their direction. Sometimes men and boys assisted with heavier work, but they still answered to the women. Usually, the ground was cleared about mid-March and corn planted. Around mid-April, final tilling was done and the people left for the spring buffalo hunt. Upon returning, the corn was ready to be eaten as roasting ears.

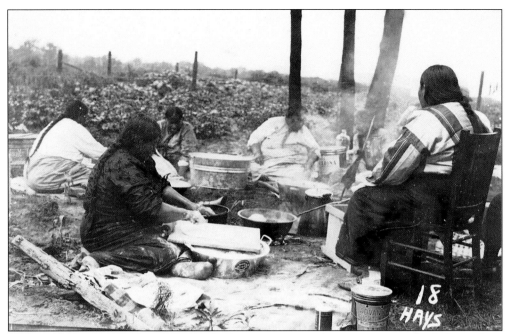

OSAGE WOMEN PREPARING FOOD. Early Osage women used two roasting methods for cooking meat. First, the meat was wrapped in leaves which was then covered with ashes, then placed on a bed of live coals. Another method involved suspending the meat by a vine over a fire. Next to roasting, stewing and boiling were widely used cooking methods.

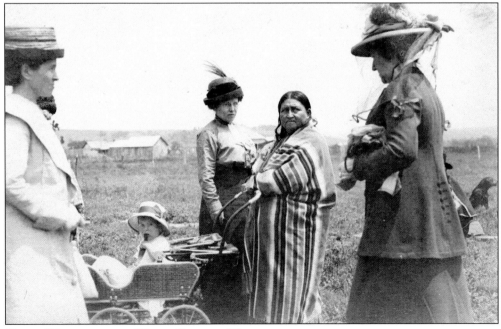

OSAGE WOMAN AMONG WHITE PIONEER WOMEN.

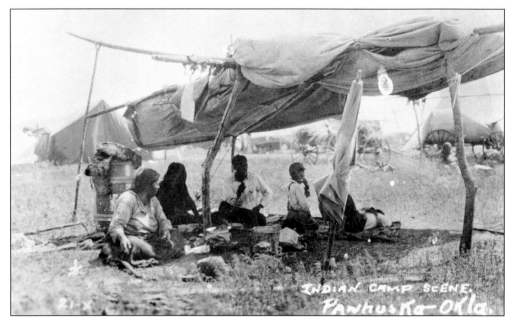

INDIAN CAMP SCENE. More than 200 Osages moved onto a reservation between the Arkansas River and the 96th Meridian, in the eastern end of the Cherokee Outlet. This was not part of the Cherokee Nation, but was controlled by the Cherokee National Council. The Osages came from their diminished reservation along the Neosho River in Southeastern Kansas, centered by present-day St. Paul. The new reservation in Indian Territory approximated Osage County.

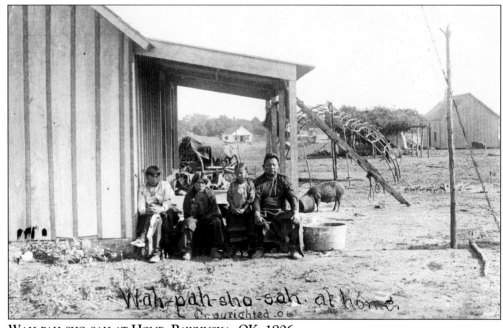

WAH-PAH-SHO-SAH AT HOME, PAWHUSKA, OK, 1906.

OSAGE BABY. Tribal customs demanded that an Osage baby be named in order to become an official member of the tribe. After the first three sons and first three daughters had been ceremonially named, subsequent sons or daughters did not go through the ceremony.

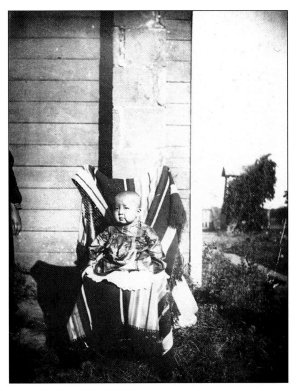

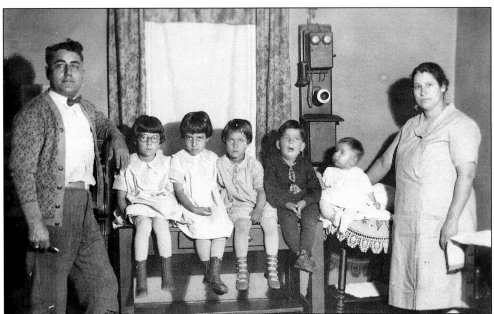

OSAGE FAMILY INSIDE THEIR HOME. During the late 1800s, when the Osage were removed from their Kansas home to Indian Territory, every family who fenced at least five acres of farmland was encouraged to build permanent housing. Between 1873 and 1875, more than 200 homes were built. Each family that agreed to live in a house received tables, chairs, brooms, washboards, cups, saucers, knives, and forks.

WAH-PAH-SHO-SAH, 1906.

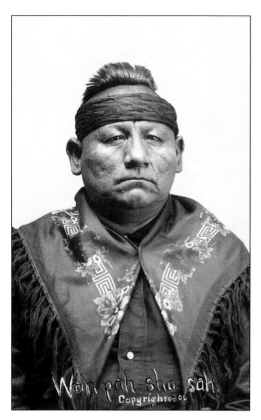

OSAGE ROPE MAKER, FAIRFAX, OK, 1923.
Note the tattoos on his chest and the distended earlobes caused by the cutting of the ear to hold heavy earrings. Both were considered marks of distinction by the Osage.

BAH-SOOTH-SAW (SITTING) AND PERRY KING (STANDING).

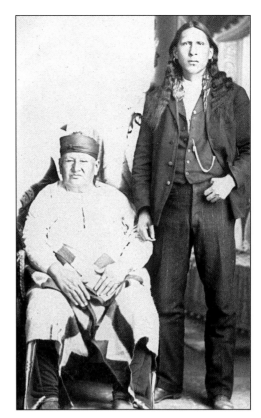

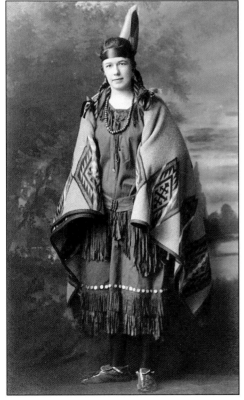

EMILY TAYLOR. Traditional Osage clothing included moccasins. Ceremonial moccasins were one piece and seamed down the toes in a single seam. Everyday and dress moccasins were made in two pieces with a single top piece sewn to a sole. Moccasins normally had a cuff turned down over a tie string. The string and cuff ran from a front slit, around the heel, and back to the front.

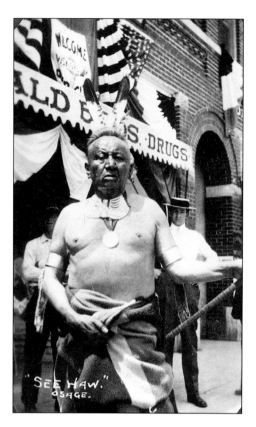

SEE HAW, PAWHUSKA, OK, C. 1955. See Haw spoke only the Osage tribal language. The Osage were one of the five tribes in the Dhegiha group of the Siouan linguistic family. The others are Omaha, Ponca, Kaw, and Quapaw.

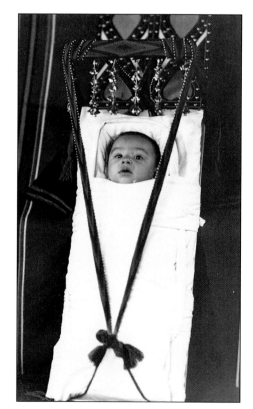

JOHN HICKEY, PAWHUSKA, OK. This photograph of John was taken when he was four months old. John's grandmother hand-crafted the beaded cradle board.

EDITH WARE AND PAPOOSE, PAWHUSKA, OK. The Ware family were early settlers of this area. In 1890, M.C. Ware farmed and raised stock just south of Pawhuska. He also raised Kaffir corn and sugar cane. In 1891, Ware married Agnes Martin and together they had eight children.

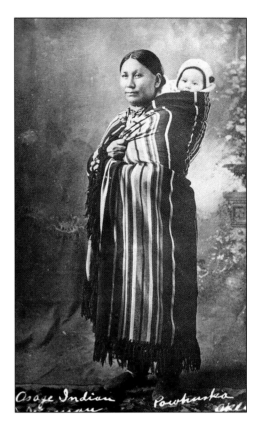

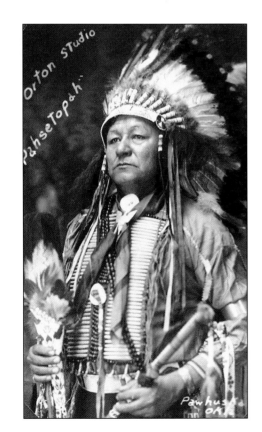

PAH-SE-TO-PAH, FLUTE PLAYER, PAWHUSKA, OK. The flute maker's art is an ancient tradition and each tribe has its own myth of how the flute was given to the people. The Osage flute player was also charged with being the Keeper of Ho-Tah-Moie, or John Stink, who was a well-known hermit due to his illness.

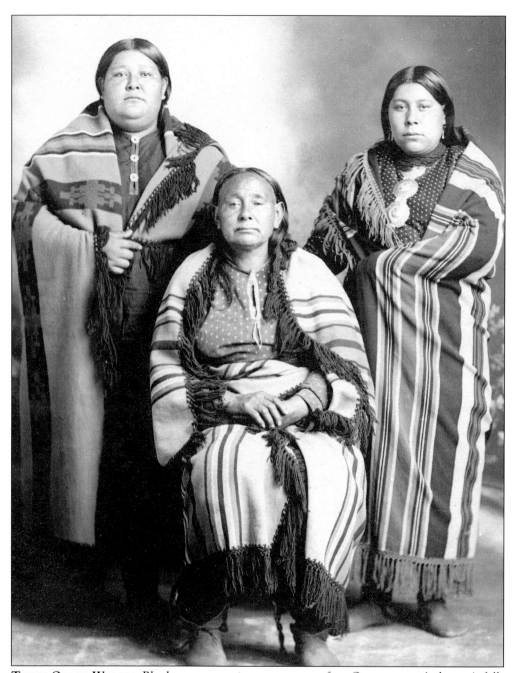

THREE OSAGE WOMEN. Blankets were an important part of an Osage woman's dress. A full-length blanket was long enough to cover the body down to the calf of the legs. Fabric trade blankets became popular and came in one, two, and three-stripe grades. A one-stripe usually cost one prime beaver pelt, two stripes cost two pelt, and so forth. Later, blankets appeared in many vari-colored stripes and a variety of designs. Blankets are worn with the stripes appearing vertically. Sometimes a wide black fabric with stripes along one side was available and sold by the yard. Blankets made of this fabric were often adorned with ribbon work.

PAUL RED EAGLE AND HIS WIFE. Traditional Osage recognized two forms of marriages: *Me shin*—"the unmarried" and *Ome ho*—"married before." Several ceremonial events were connected with the marriage process including the exchange of gifts between the two families. Marriage was not allowed within the same clan.

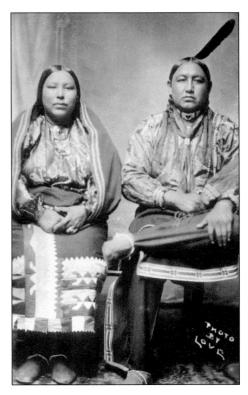

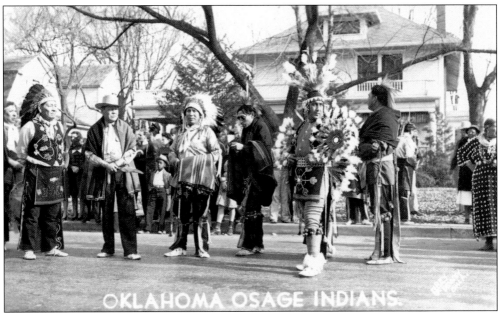

OSAGE INDIANS, OSAGE COUNTY, OK. In 1870, the Osage sold their land in Kansas and purchased a reservation in Indian Territory. This land proved to be rich in oil and was developed as the Osage Lease. In 1881, the tribe formed the Osage Nation. The reservation was held in common until 1906 when a tribal roll was created and each member of the tribe received a share of the oil royalty.

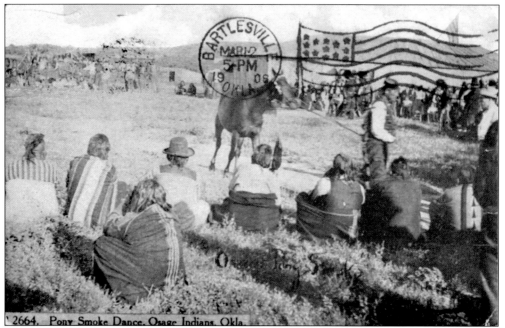

PONY SMOKE DANCE, OSAGE COUNTY, OK, C. 1908.

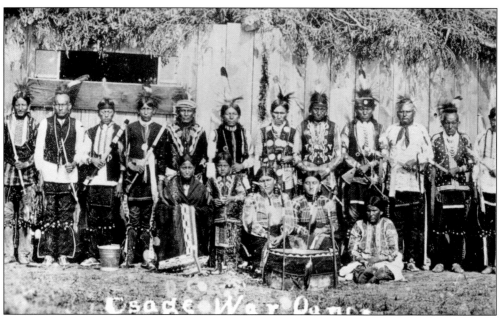

OSAGE WAR DANCE, PAWHUSKA, OK. The leader of a war party was called To tun hun ka– "Sacred One of the War Party." Although he accompanied the war party, he did not direct the party or participate in the fighting. His function was spiritual and he concentrated on prayers to Wa kon ta.

Four

BUILDINGS AND BUSINESSES

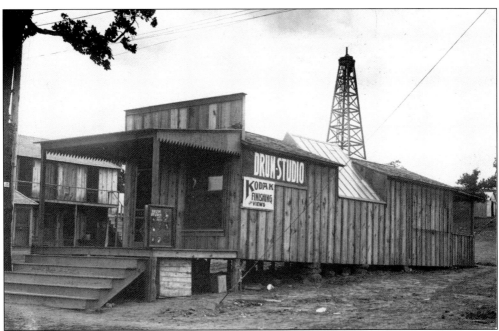

DRUM STUDIO, BARTLESVILLE, OK. Periodically, Oscar Drum, an early photographer, set up a trailer-studio north of the Morgan and Clay blacksmith shop. He later operated a railroad car studio after the tracks reached Bartlesville. When the Masonic Building was completed in 1907, Drum put in a new photographic gallery on the second floor.

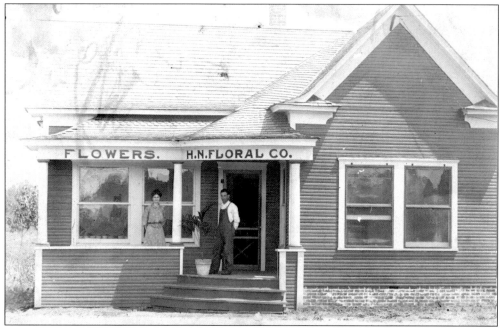

H.N. Floral Company, Bartlesville, OK. The florist shop was located at 400 E. Third in 1906 and owned by George W. and Florence Neyhord.

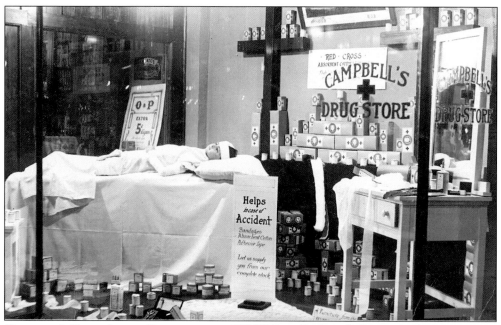

Campbell's Drug Store, Bartlesville, OK. William B. Campbell came to the area in 1910 and worked as manager of the Red Cross Drug Store, at 107 East Second. The following year he bought the store from Fred McDaniels, who had built it in November 1906. Campbell renamed the store Campbell's Red Cross Drug Store. In 1915, he moved the store to 317 Dewey and dropped "Red Cross" from the name.

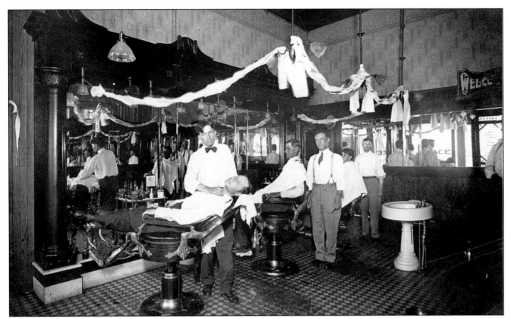

BARBER SHOP, OCHELATA, OK. Alex Hendrix was an early barber who operated a shop in Ochelata.

GIBSON'S TAILORING AND DRYCLEANING SHOP, DEWEY, OK 1908. Note the treadle sewing machine in the photograph. Wives of the tailors often served as the seamstresses in these early businesses.

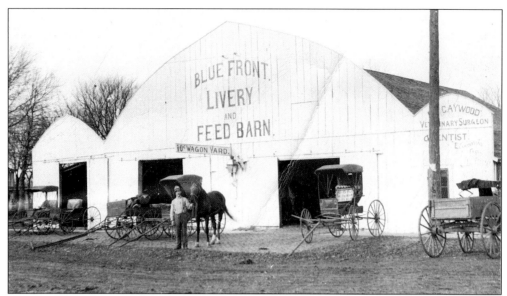

BLUE FRONT LIVERY AND FEED BARN, OCHELATA, OK. The livery shared the building with Dr. Caywood's veterinary business. Dr. Caywood was a surgeon and a dentist. Veterinarians often had liveries as a second business, needing the facilities to keep livestock while administering medicine.

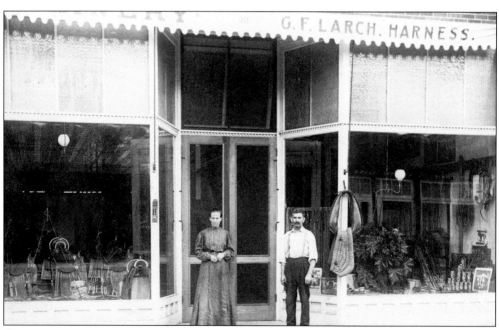

G.F. LARCH HARNESS SHOP, BARTLESVILLE, OK, 1908. Elizabeth and G.F. Larch stand in front of the shop located on Second Street.

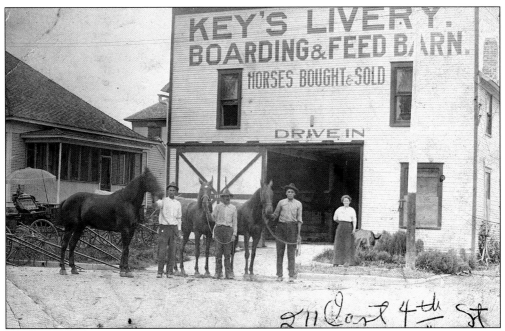

KEY'S LIVERY, BARTLESVILLE, OK. In 1913–14, the livery was located at 211 East Fourth Street and owned by LeRoy H. Keys.

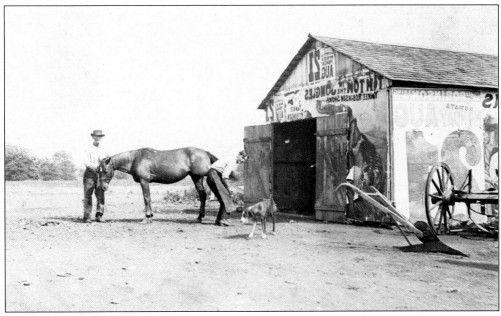

BLACKSMITH'S SHOP. The second business to be set up on the south side of the Caney River was a blacksmith and cabinet shop by a man named Graham. In 1887, A.I. Morgan bought out Graham, and in 1889 was joined by Henry Clay. The partnership was dissolved after 1889 when Morgan was appointed as the settlement's second postmaster, succeeding Jacob Bartles.

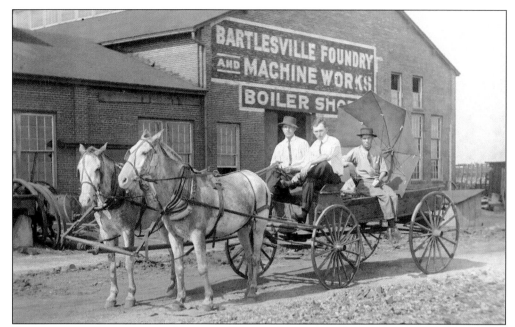

BARTLESVILLE FOUNDRY AND MACHINE WORKS. Located one mile southwest of the city, the foundry was established before 1907, but was out of business by 1912. The president of the company was Dr. R.D. Rood, G.B. Keeler served as vice president, J.H. McMorrow was the secretary and treasurer, and B.J. Barringer was general manager.

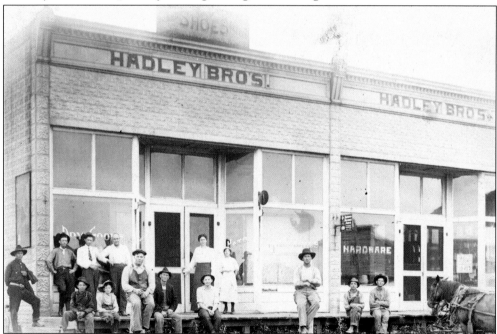

HADLEY BROTHERS DRY GOODS AND HARDWARE STORE, VERA, OK. Businesses were built in Vera and a post office was established in December 1899, with Eli Carr as the postmaster. In 1900, the Santa Fe railroad was built through the region and the settlement centered around the depot.

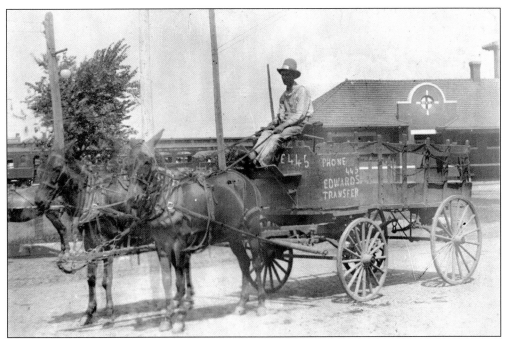

EDWARDS TRANSFER, BARTLESVILLE, OK. A mule-drawn wagon of Edwards Transfer sits in front of the AT&SF depot. In 1910, the company was located at 500 Dewey with Thomas Edwards as proprietor.

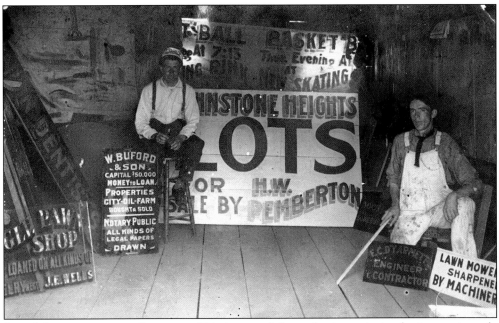

SIGN MANUFACTURING COMPANY. This is one of the early sign painting businesses in early Bartlesville. City directories list sign painter, Sid M. Jones in 1907, Jones and Shellor at 310 S. Dewey in 1908–09 and 1910, and Herb H. Shellor at 207 E. Second in 1912.

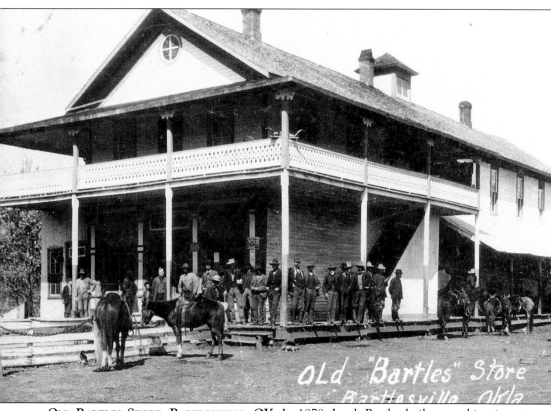

OLD BARTLES STORE, BARTLESVILLE, OK. In 1878, Jacob Bartles built a combination store and home near the horseshoe bend of the Caney River. The building was constructed of black walnut and was stocked with groceries, clothing, harnesses, furniture, farm equipment, and wagons—all the necessities for life on the frontier. The family quarters were located on the second floor. Bartles later moved the building, using log rollers, three miles north to a wheat field. This was the beginning of the town of Dewey.

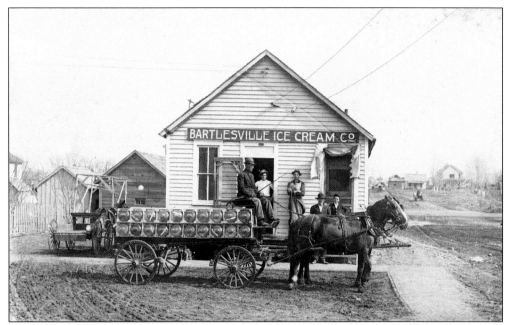

BARTLESVILLE ICE CREAM COMPANY, BARTLESVILLE, OK. The 1908–09 City Directory lists the ice cream company at 122 Osage with Lewis Rittersbacher, Peter Remler, and John Sexton as owners. Fletcher Pomeroy constructed the wagons which were used to deliver the ice to homes.

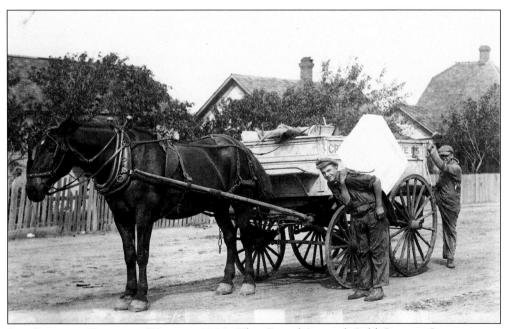

ICE COMPANY DELIVERY WAGON, 1920. The Crystal Ice and Cold Storage Company was started by Harry McClintock in 1903. The name of the horse is "Old Snap."

FIRST STORE, VERA, OK. This store was owned and operated by Mr. and Mrs. C.A. Hadley. It was one of the first stores in the town along with one operated by William C. Rogers, Principal Chief of the Cherokee Nation.

RITTER STORE, BARTLESVILLE, OK. Business news in a 1905 local newspaper told of P. Voille Ritter opening a grocery store at 123 West Third Street. Mr. Morse is standing by the pumpkins.

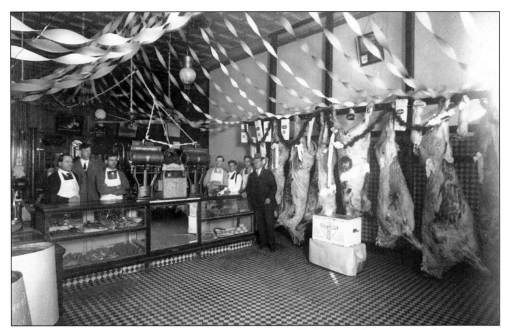

INTERIOR OF MEAT MARKET. What the newspaper called "the oldest meat market in town" became the sole property of John Johnstone in 1903 when he purchased the interest of Harve Pemberton. The Little Giant Grocery Store, operated by Easter and Vandaveer, was in the Fowler Building at 203 E. Second Street. The 1907 city directory lists Alex C. Easter and George W. Gelbach as proprietors.

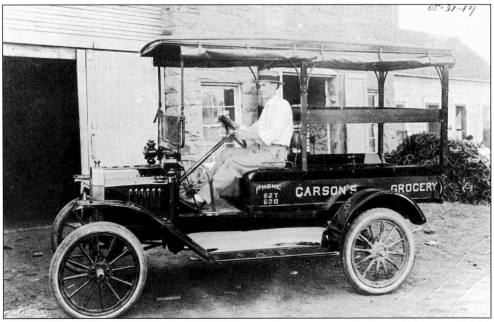

CARSON'S GROCERY DELIVERY TRUCK. In 1912, Henry Carson worked as a clerk in Waukesha Grocery store owned by Marion B. Price. The following year, Henry and R. Pearl Boyd owned and operated the Boyd and Carson Grocery, and in 1915, Henry and his wife Rosa owned Carson's Grocery located at 225 E. Third Street.

FRANK GOUGLER STORE, OGLESBY, OK, C. 1912. The first store in Oglesby was opened in 1898 by Tom Oglesby. Located 14 miles southeast of Bartlesville on the banks of the Caney River, the small community soon grew and was granted a post office on November 13, 1900. A sawmill and gristmill were quickly constructed along the banks of the river.

EARLY TAXI, 1907. On February 25, 1898, the first taxi from Caney, Kansas, to Bartlesville was established. The first driver was Jake Bisel. This photo shows the taxi in 1907 with driver, William M. McCausland.

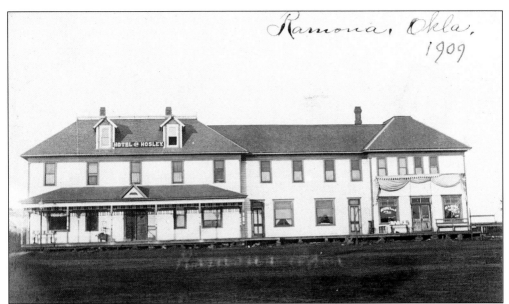

HOTEL DE HOSLEY, RAMONA, OK, 1909. R.W. de Hosley, known as "Darb," headed the building procession in Ramona by erecting the Hotel de Hosley around 1904. He later added a 24-room addition to the hotel. The hotel was popular with oil men developing the nearby oil fields. Guests stayed in the left wing of the building, while the right wing was rented to oil property agencies.

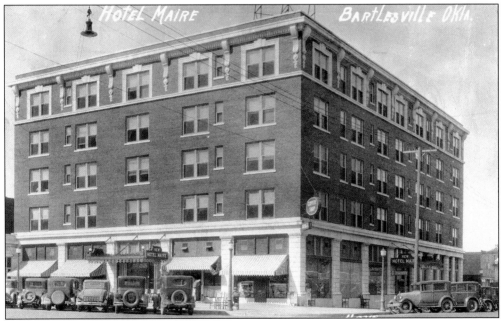

MAIRE HOTEL, BARTLESVILLE, OK. A 1912 newspaper reported that citizens will build a $120,000 hotel at Fourth and Johnstone, with an appointed committee to raise the $35,000 needed to put the deal through. The hotel was built in 1913 by the Maire brothers of Lima, Ohio. The hotel later became the Burlingame Hotel, then the Phillips Building Annex, and most recently the home of the City Administration and History Museum.

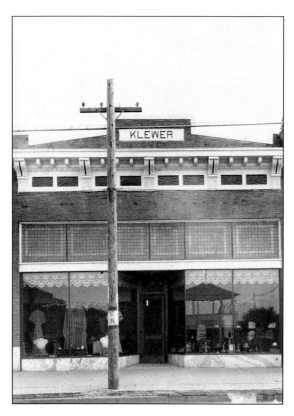

KLEWER'S DRY GOODS STORE, DEWEY, OK. Mr. and Mrs. C.J. Klewer moved to Dewey in 1910. They purchased and operated the Joe Bartles Dry Goods Store and later built their own dry goods store. It became known as Peter's. Klewer was also president of the Security National Bank, which later merged with the First National Bank.

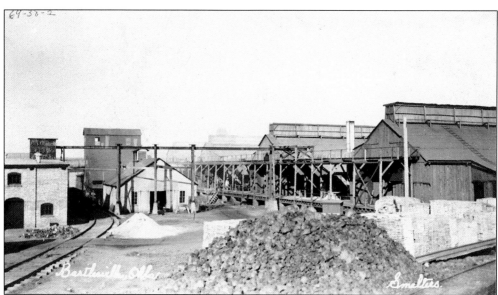

SMELTERS, BARTLESVILLE, OK. The Commercial Club was successful in attracting three smelters to Bartlesville: the Lanyon-Starr smelter was built in 1906; Bartlesville Zinc Company arrived in March 1907; and in April 1907, National Zinc Company located here. The industries were concentrated on the western edge of the community in a section known as "Smeltertown." The escaping fumes from the smokestacks often created a blue haze over downtown Bartlesville.

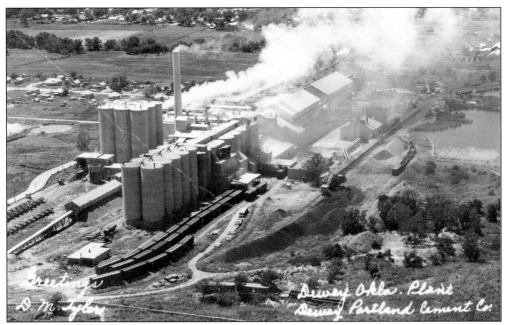

DEWEY PORTLAND CEMENT PLANT, DEWEY, OK. Brothers Frank and Herbert Tyler organized the cement company in 1906. Incorporated with a million dollars paid-up capital, the plant employed more than 300 men at is peak. The first cement made in the state of Oklahoma was produced at this plant in 1908, its first year of operation.

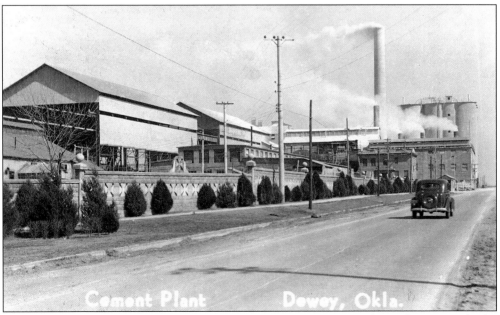

DEWEY PORTLAND CEMENT PLANT. Another first was the building and use of concrete silos for the storage of cement. In order to find sufficient limestone for the plant, the company dispatched search crews throughout Washington County. Eventually the company opened several quarries to supply the cement plant with limestone.

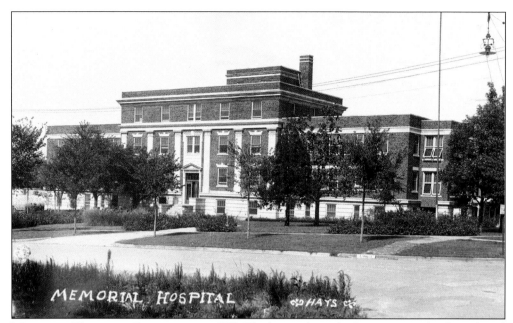

MEMORIAL HOSPITAL, BARTLESVILLE, OK. The hospital was built in 1922 on land purchased on the George B. Keeler residential block. Many local citizens, organizations, and doctors furnished rooms and equipment. For a time, the hospital served as a memorial to those who had served in World War I. Any veteran of any United States war could be treated free of charge.

BARTLESVILLE STATE BANK, BARTLESVILLE, OK, JULY 1, 1916. The bank was located at Third Street and Dewey Avenue with Frank C. Raub as president, George R. McKinley as cashier, and James C. Hagerman as assistant cashier. The bank was first listed in the 1910 city directory.

FIRST NATIONAL BANK, DEWEY, OK. Formed in 1900, the First National Bank occupied this building on the corner of Eighth and Delaware. Through a merger with the Citizens Bank and Trust, Frank Phillips became chairman, a position he held for many years.

FIRST NATIONAL BANK, BARTLESVILLE, OK, LOCATED AT THE CORNER OF FOURTH STREET AND JOHNSTONE AVENUE.

WASHINGTON COUNTY WAR SAVINGS STAMP BANK, BARTLESVILLE, OK, JUNE 23, 1918. The original structure was located at Third Street and Johnstone Avenue. The building was changed and relocated to 728 South Oak Street. It was later reproduced in solid concrete by H.F. Tyler at his home at 1101 Johnstone Avenue.

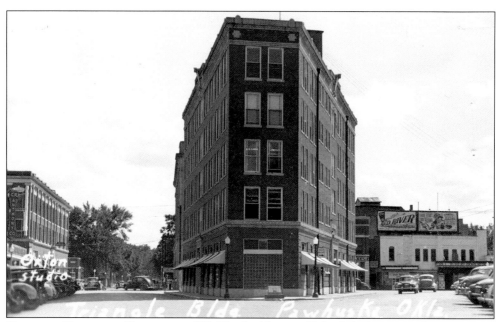

TRIANGLE BUILDING, PAWHUSKA, OK. The building, at Ki-he-kah Avenue and Main Street, is located on the site of the first station for disbursing funds to the Osage Tribe. A hitching rail originally enclosed the area which included the traditional bandstand. Pawhuska businessmen later purchased the triangular plot to erect the modern building.

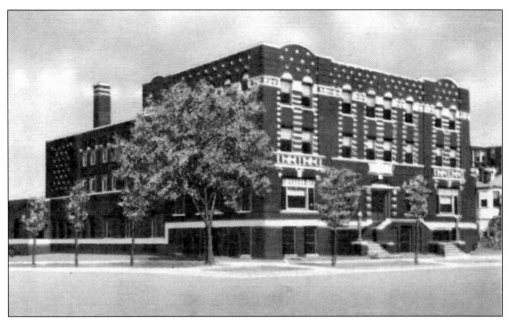

YMCA, BARTLESVILLE, OK. When the Open House was held on October 29, 1917, Bartlesville residents were quite proud of the YMCA's modern and up-to-date facility with a library, reading room, pool, and volleyball and handball courts.

PHILLIPS PETROLEUM COMPANY, BARTLESVILLE, OK. The oil company's first office building, the Frank Phillips Building, was built in 1925. In 1927, an eighth floor and a tower were added.

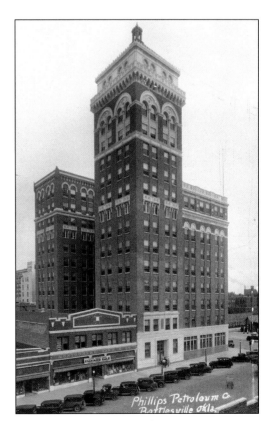

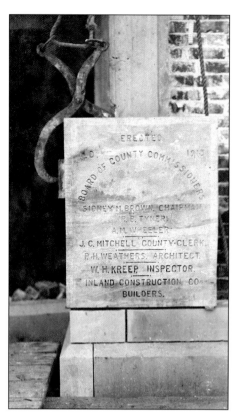

COURTHOUSE CORNERSTONE, BARTLESVILLE, OK, 1913. Members of the Masonic Lodge laid the Washington County Courthouse cornerstone. The stone is inscribed "Erected 1913 AD, Board of County Commissioners, Sidney M. Brown, Chairman; R.B. Tyner; A.M. Wheeler; J.C. Mitchell, County Clerk; P.H. Weathers, Architect; W.H. Kreep, Inspector; Inland Construction Co., Builders." The cornerstone is located on the north side of the courthouse.

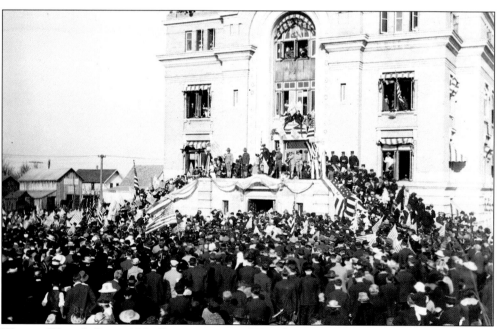

WORLD WAR I CALL 190, BARTLESVILLE, OK. The men and boys wait in front of the Washington County Courthouse.

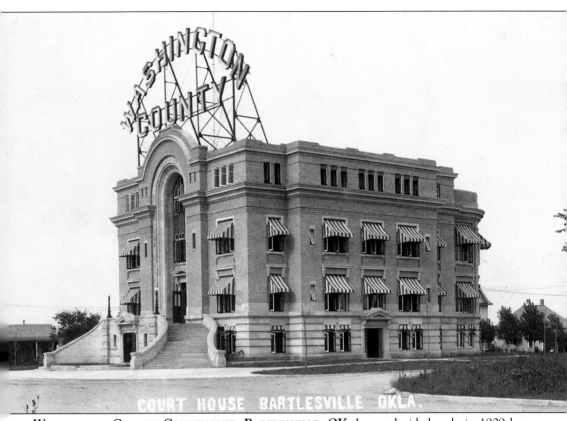

WASHINGTON COUNTY COURTHOUSE, BARTLESVILLE, OK. It was decided early in 1909 by the county government to build a courthouse on Third Street between Delaware and Shawnee Avenues, near the east end of the business district. It took three votes before this was passed in a bond issue vote of $115,000 in April 1912.

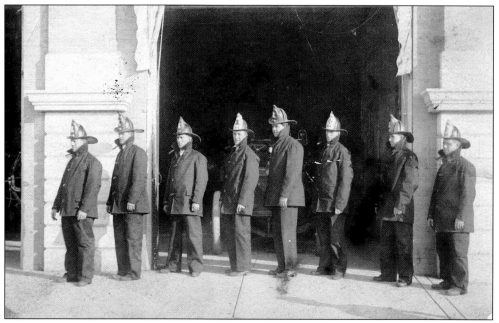

FIREMEN, BARTLESVILLE, OK.

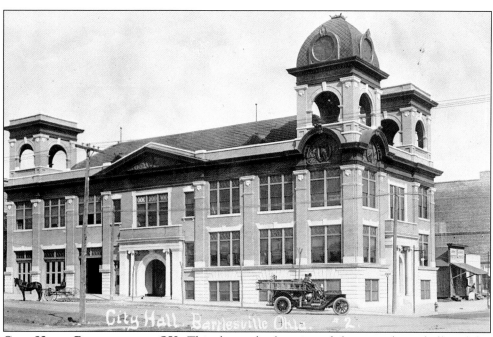

CITY HALL, BARTLESVILLE, OK. This shows the location of the second city hall and fire department located at the northwest corner of Fourth Street and Dewey Avenue in 1910. The police department and jail were on the ground floor, the city offices on the second floor, and the Chamber of Commerce occupied the third floor.

Five

STREET SCENES

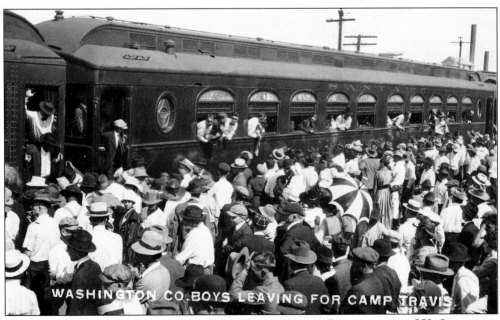

WASHINGTON COUNTY BOYS LEAVING FOR CAMP TRAVIS, BARTLESVILLE, OK, SEPTEMBER 1917.

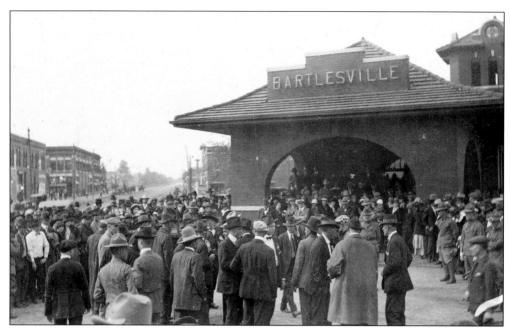
WORLD WAR I SEND-OFF, BARTLESVILLE, OK, 1918.

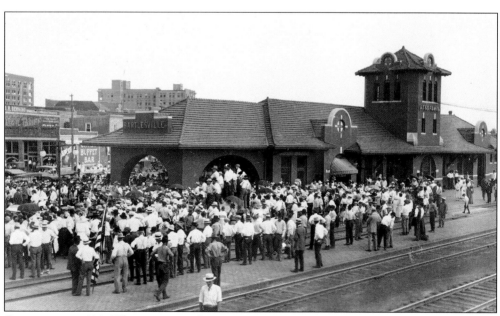
CROWD AND 120 WASHINGTON COUNTY DRAFTERS AT THE BARTLESVILLE STATION, BARTLESVILLE, OK, JULY 22, 1918.

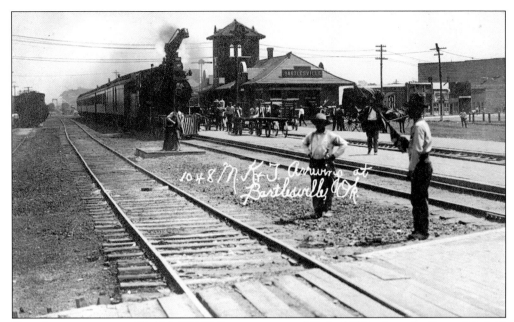

THE ARRIVAL OF THE 10:48 MK&T, BARTLESVILLE, OK. In 1900, when the Santa Fe's 3:40 p.m. west bound passenger train #267, known as the "Creeper," was ready to depart, one would hear the station master call "All aboard for Matoaka, Ochelata, Ramona, Vera, Collinsville, and Owasso, all aboard." Just prior to this time, these communities were called Funston, Otis, Hobson, Evana, Collins, and Elm Creek, respectively.

MK&T PASSENGER TRAIN WRECK, BARTLESVILLE, OK, SEPTEMBER 24, 1914. The wreck occurred about 150 yards south of the bridge across the Caney River, within site of the depot. The *Morning Examiner* reported the reason was an open switch that caused the train to divert to a side track, striking a string of box cars. The impact caused the train to turn over, but few passengers received serious injuries.

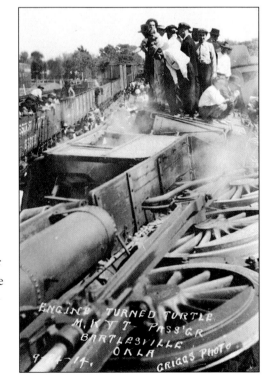

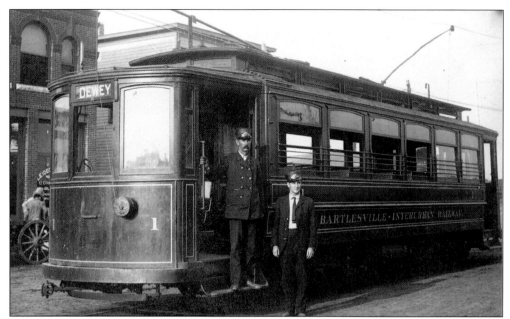

INTERURBAN RAILWAY CAR, BARTLESVILLE, OK. Guy Woodring is on the right. The Interurban started running in 1908 and ran until 1920. It ran from the smelters to Dewey through Tuxedo. Two bridges were constructed over Coon Creek and the Caney River for the streetcars. A round trip cost about 20¢ and took about 45 minutes.

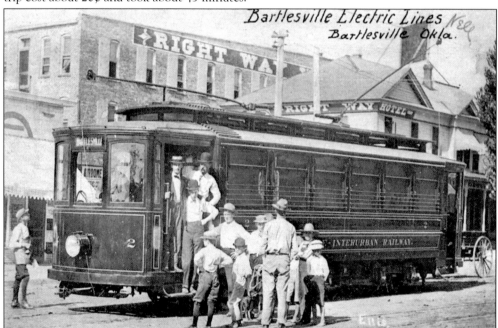

BARTLESVILLE INTERURBAN STREETCAR. The terminal, brick power house, and car barn were constructed on Fourth and Comanche. In 1915, a south loop was constructed which started at Fourth and Wyandotte, ran south to Ninth, west to Delaware, south to Thirteenth, west to Keeler, north to Eighth, east to Dewey, and north to Third. Half-hour service was given on this loop.

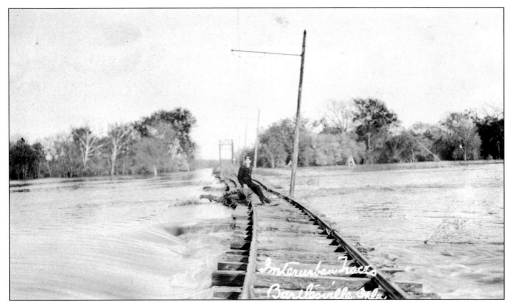

INTERURBAN TRACKS ON EAST FOURTH STREET, BARTLESVILLE, OK. In the background is the bridge over the Caney River. The 1908 news noted that the flooding of the Caney reduced the Interurban tracks through the river bottom to a wrecked and tangled mess. At times, Bartlesville was literally surrounded by water.

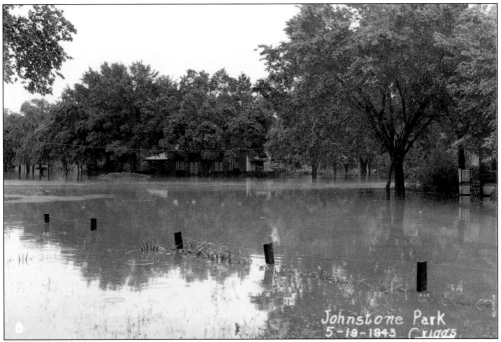

JOHNSTONE PARK, BARTLESVILLE, OK, MAY 19, 1943. The flooding of early Bartlesville businesses located near the Caney River, as seen in this photograph, forced business buildings to be moved to the west away from the river before 1907.

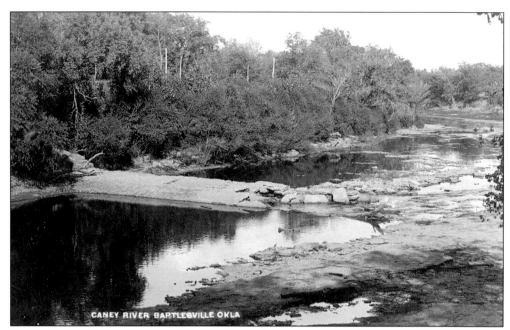

CANEY RIVER, BARTLESVILLE, OK. The Caney River rises in the flint hills of Kansas and runs almost due southeast, entering Oklahoma at a point about 20 miles north of Bartlesville.

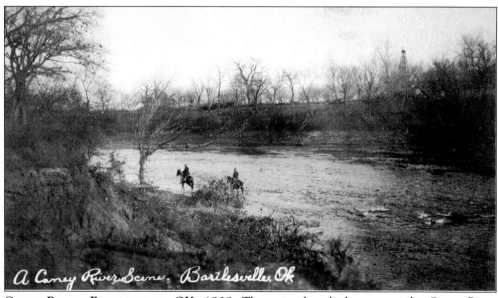

CANEY RIVER, BARTLESVILLE, OK, 1909. The natural rock dam across the Caney River provided a convenient ford over the waterway. Impounded water of the upstream side also offered fishing and boating for local residents. Early settlers used as many as 15 natural fords to cross the Caney River. Most of these became crossroads for early trails.

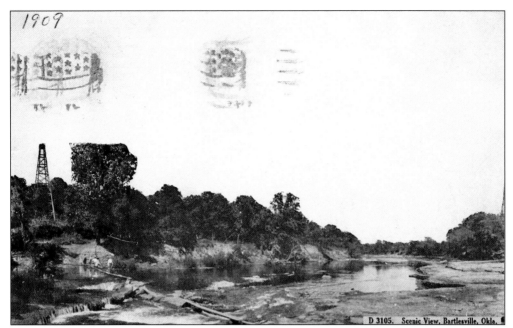

CANEY RIVER, BARTLESVILLE, OK. The Caney River provided a convenient means of transportation for early settlers. As early as 1896, Joe Bartles, L.M. Drown, and Charles Ryan operated a 14-foot clinker boat up and down the waterway. The *Aunt Nannie* was a vessel operating on the river for recreational purposes. William Johnstone charged customers 25¢ to haul a wagon and team across the river on his ferry boat.

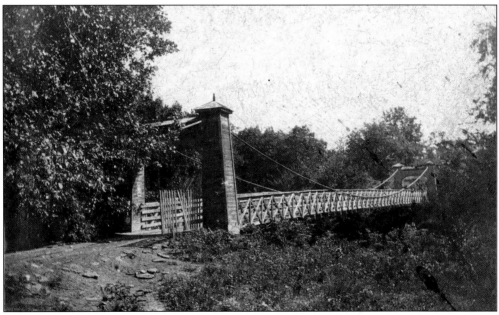

TOLLBRIDGE OVER THE CANEY RIVER, BARTLESVILLE, OK. A toll bridge was constructed over the Caney River near Armstrong's Ford to be used when the waterway was in flood. Cables were anchored in the ground to support the wooden-floored bridge connecting property owned by William Johnstone and James Day.

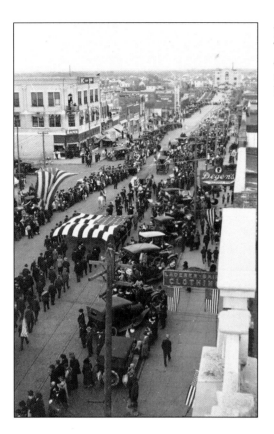

DOLLAR DAY PARADE, BARTLESVILLE, OK. This 1913 parade stretched from the corner of Third Street and Johnstone Avenue all the way to the courthouse at Third and between Delaware and Shawnee Avenues.

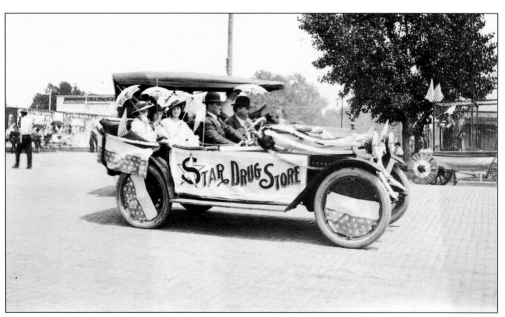

STAR DRUG STORE PARADE ENTRY, 1915. At the first Dollar Day parade on May 12, M.R. Puckett entered this float, which is seen passing through the intersection of Fourth Street and Dewey Avenue.

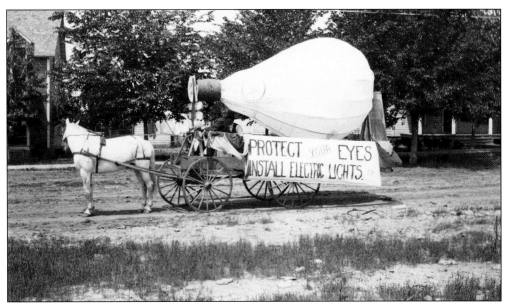

"Bright Idea," Bartlesville, OK, May 12, 1915. The mammoth light bulb in the Dollar Day parade was the Bartlesville Interurban Railway Company Float.

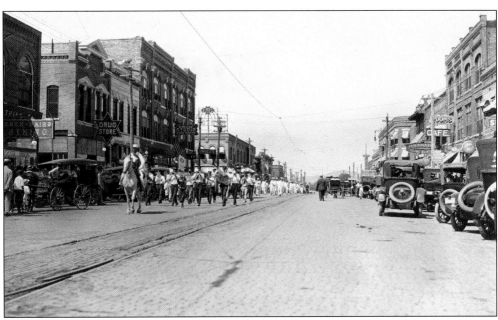

Labor Day Parade, Bartlesville, OK, September 4, 1916. This photograph of the parade was taken on West Third Street.

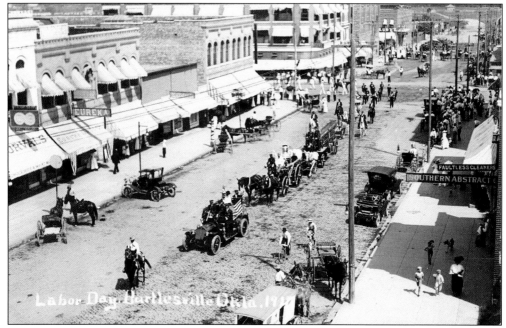

LABOR DAY, BARTLESVILLE, OK, 1917.

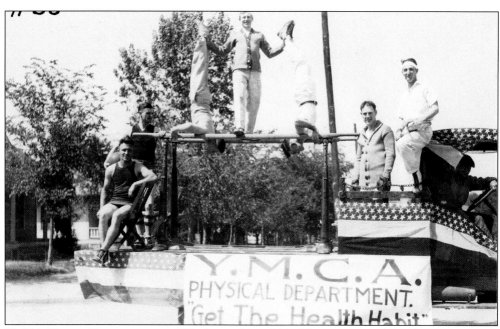

YMCA FLOAT, BARTLESVILLE, OK, APRIL 30, 1920. This was part of the Americanization Day parade that was held in conjunction with the Americanization Movement. The Movement culminated in a conference, attended by state governors of the National Bureau of Education and the National Committee on One Hundred, in 1918, just prior to U.S. entry into World War I. The conference reflected the unease of America at the Communist Revolution in Russia.

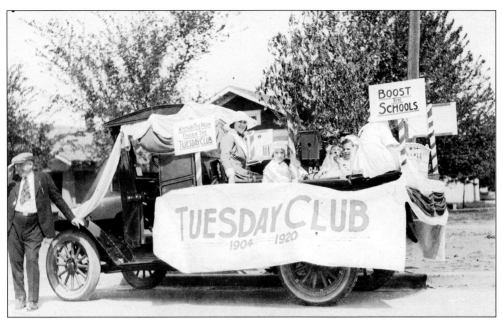

TUESDAY CLUB FLOAT, BARTLESVILLE, OK, APRIL 30, 1920. Evolved from the Fortnightly Club and dating to 1904, the Tuesday Club founded the public library by holding a book shower and persuading the city administration to appoint a library board. The club worked to obtain a grant of $12,500 from the Carnegie Foundation, which established the library building at Seventh and Osage. The library was at this location for 15 years.

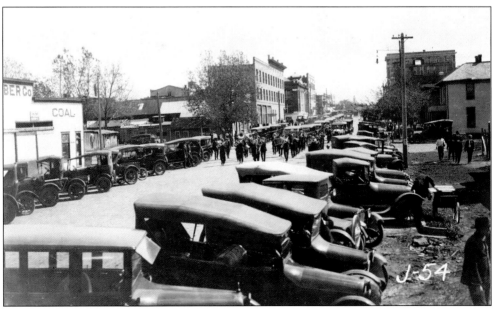

LOOKING SOUTH ON DEWEY AVENUE, BARTLESVILLE, OK, APRIL 22, 1921. Across First Street from the ball park, the Masonic Band leads a baseball parade down Dewey Avenue to Johnstone Park for the opening game of the Southwestern League with the Sapulpa Rajas.

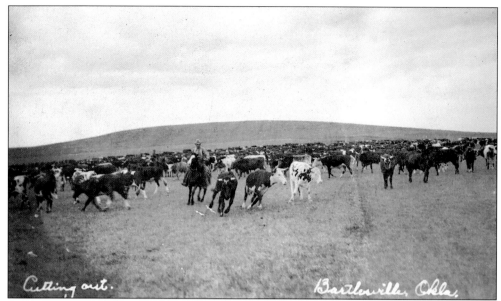

CUTTING OUT CATTLE, BARTLESVILLE, OK. Washington County's rich grasslands attracted early day cattlemen to the region. However, the open range eventually gave way to fenced pastures as improved breeds of cattle were introduced.

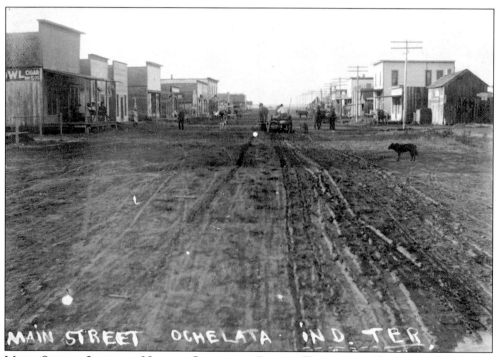

MAIN STREET LOOKING NORTH, OCHELATA, INDIAN TERRITORY. The town of Ochelata was created around 1900 when Thomas Ellis bought land from a Cherokee, Jacob Dick, in accordance with provisions of the Curtis Act. Ellis gave his town the Indian name of Charles Thompson, Principal Chief of the Cherokees from 1875 to 1879. The post office was established on March 23, 1900.

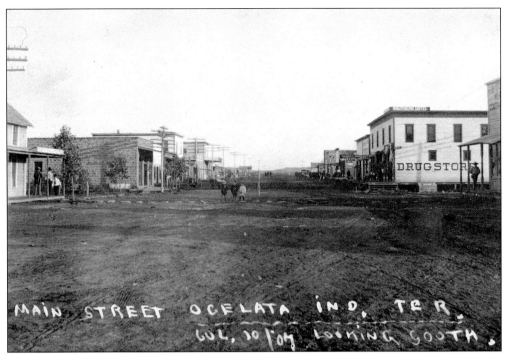

MAIN STREET LOOKING SOUTH, OCHELATA, INDIAN TERRITORY. The town of Ochelata was granted a post office in March 1900, and was incorporated in 1902 with Nick Taylor as mayor. The town was the center of an early oil boom shortly after statehood, and attracted numerous merchants and businessmen. Some of these included Campbell's Meat market, J. Hammond's blacksmith shop, and Dr. Rowland's Drug Store.

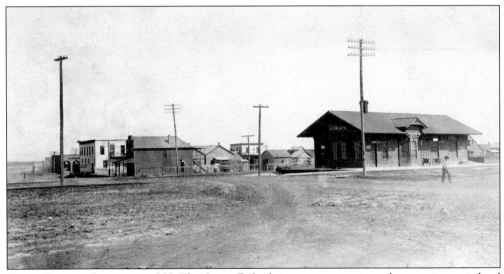

TRAIN DEPOT, OCHELATA, OK. The Santa Fe had six passenger trains a day carrying mainland baggage, which was convenient for those traveling to Bartlesville or Tulsa. The station was a popular gathering place on Sunday afternoons when the young people gathered to watch the train come in at 3:15 p.m., and again at 4:08 p.m. The depot was built in 1899 and was retired from service December 31, 1941.

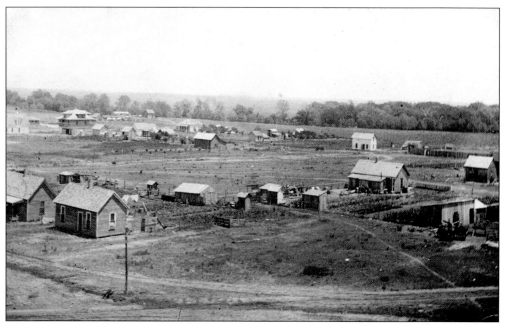

RAMONA, OK. This postcard was written by Mrs. Hosley informing Miss Maude Kelly of Ochelata that she left her bread knife when staying at the hotel.

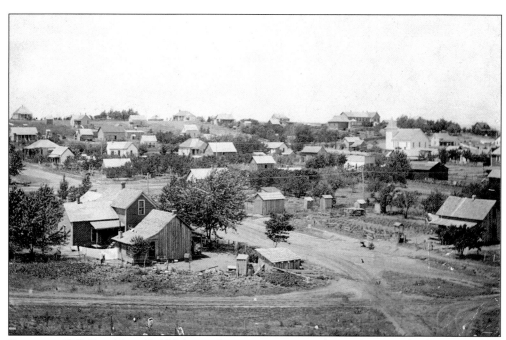

RAMONA, OK. Possibly called Hobson, the town name was changed in 1899 by the Post Office Department to Bon-Ton. Later the same year, upon agreement with the railroad company, the name Ramona was chosen for both the post office and railroad station. William Little of the Little Brothers Ranch chose the name since he had visited the settlement mentioned in Helen Hunt Jackson's novel *Ramona* and was immensely impressed.

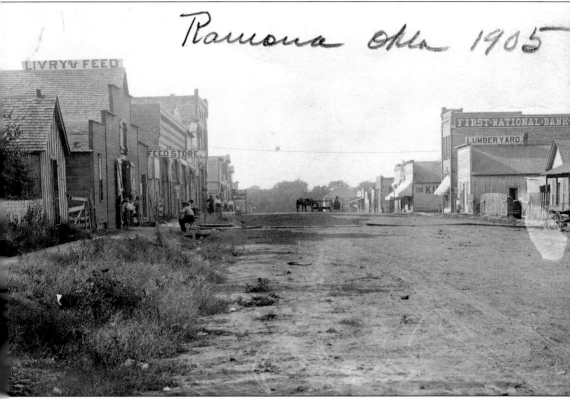

RAMONA, I.T., 1905. Jim Stokes was hired to survey the original townsite of Ramona. While there, he set up a store with staples such as flour, cornmeal, salt, molasses, jerky, sowbelly, beans, and ammunition. Stokes' customers were primarily the workmen of the new railroad. The original townsite of Ramona was located on the allotment of Jennie Cass Morton, stepdaughter of George B. Keeler, and the person who dropped the "go-devil" that blew in the Nellie Johnstone No. 1 in 1897. The thriving town had 150 inhabitants by January 1, 1900. Ramona was incorporated September 1, 1901. By 1906, Ramona had two oil well supply stores, a foundry, brick plant, mill, and several minor industries. By 1909, there were two banks, three lumber yards, hotels, a theater, millinery shop, lawyers, dentists, doctors, a good gas system, and churches. By 1912, Ramona boasted 75 automobiles!

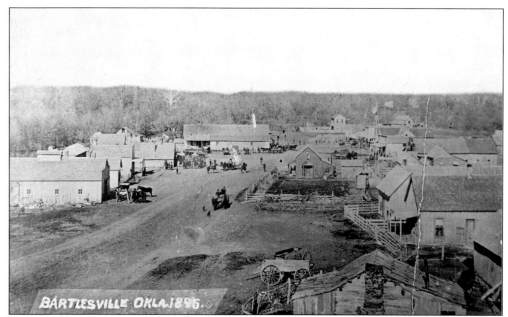

BARTLESVILLE, INDIAN TERRITORY, 1895. By 1895, the community south of the Caney River had become a trade, agricultural, and cattle center. With a population exceeding 200, the community was incorporated in 1897 as Bartlesville, Cherokee Nation, Indian Territory.

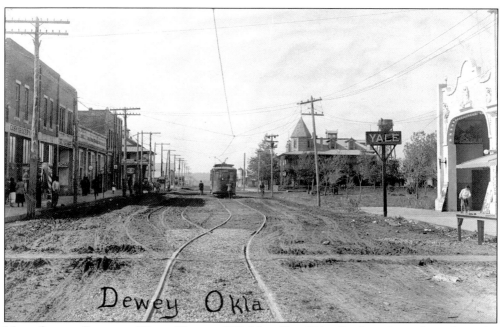

MAIN STREET LOOKING WEST, DEWEY, OK. Now Don Tyler Boulevard, on the right is the Yale Theater and the Dewey Hotel. Jacob Bartles began construction on the hotel in 1899 and by May 1900 the hotel was open for business. The parallel interurban tracks down main street intersect at the curve in the foreground.

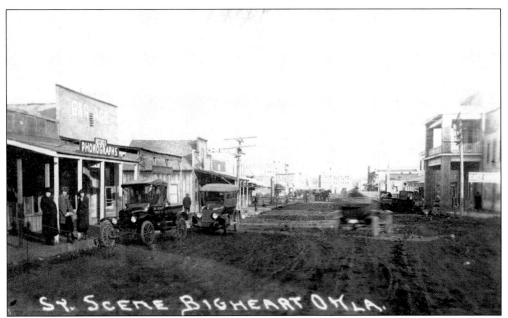

BIGHEART, OK, C. 1920. Named for Osage Chief James Bigheart, the post office was established in January 1906. The town became an important cattle shipping center and oil field siding in the Osage Hills. The name of the town was changed during the oil boom in honor of T.N. Barnsdall, who organized the Barnsdall Oil Company. The name of the post office was changed on November 22, 1921.

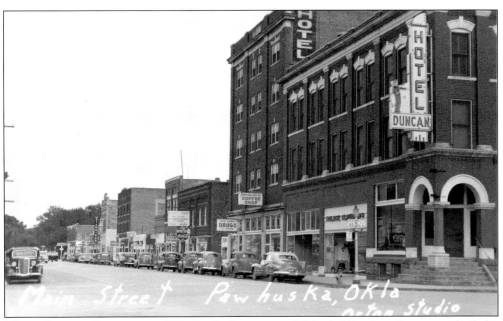

MAIN STREET, PAWHUSKA, OK. Pawhuska was established following the removal of the Osage Indians from the Silver Lake area. It is the county seat of the largest county (Osage) in Oklahoma and has been the scene of multi-million dollar oil lease auctions, as well as the site of the Osage Agency.

JOHNSTONE AVENUE, BARTLESVILLE, OK, FEBRUARY 4, 1918.

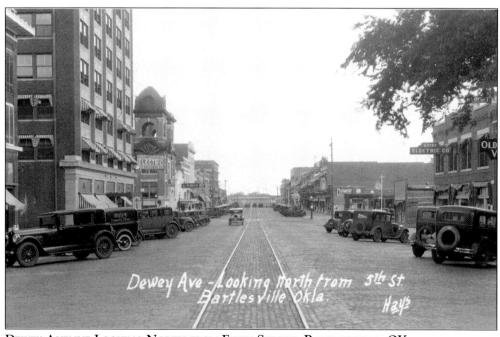
DEWEY AVENUE LOOKING NORTH FROM FIFTH STREET, BARTLESVILLE, OK.

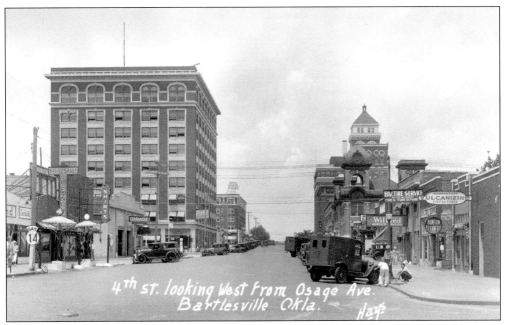

FOURTH STREET, BARTLESVILLE, OK, C. 1920. Hays was a photographer who entered business here in 1920.

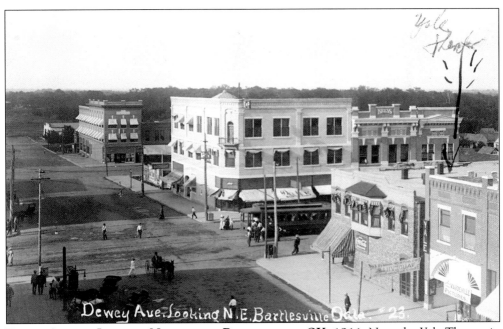

DEWEY AVENUE LOOKING NORTHEAST, BARTLESVILLE, OK, 1911. Note the Yale Theater in the bottom right-hand corner of the photo.

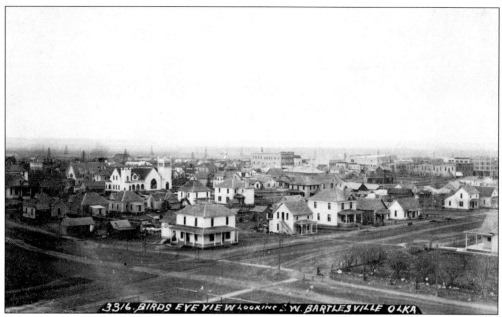
Birds-Eye View Looking Northwest, Bartlesville, OK.

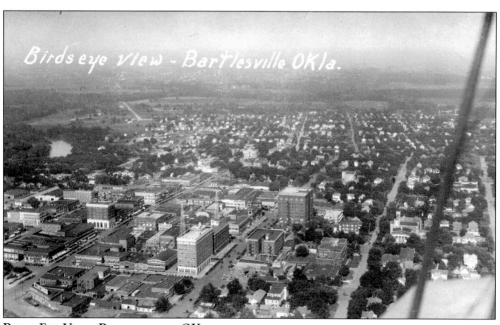
Birds-Eye View, Bartlesville, OK.

Six
PIONEERS

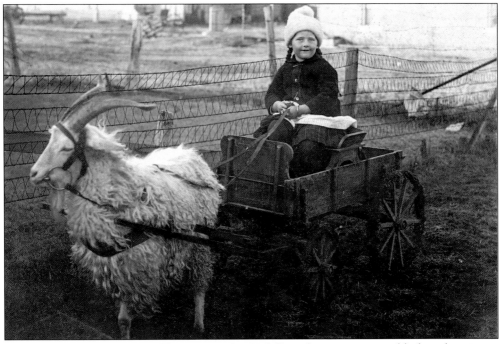

DOROTHY BELLE IN WAGON, FEBRUARY 14, 1916. Dorothy was six years old when this picture was taken.

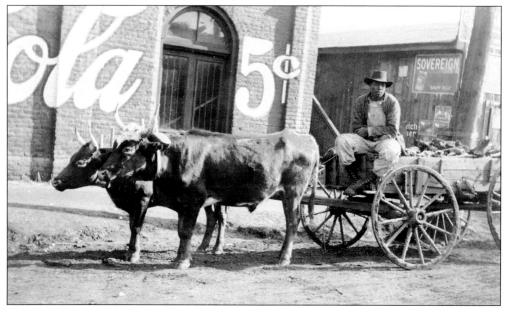
Man on Wagon Pulled by Oxen.

Ray Smith and Edna Rusk.

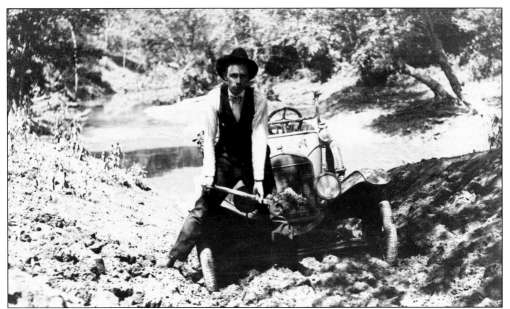

DIGGING OUT, OSAGE NATION, JUNE 10, 1917. Leon Clemmons is digging his Ford automobile out of sand on Turkey Creek ford.

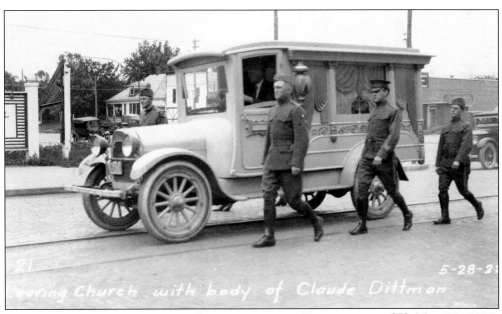

LEAVING CHURCH WITH BODY OF CLAUDE DITTMAN, BARTLESVILLE, OK, MAY 28, 1922. After undergoing surgery for appendicitis, Claude's health rapidly declined, and at age 22, the death of Claude shocked the town of Bartlesville. The American Legion organized the funeral service, which was held at the First Presbyterian Church. Claude had enlisted in the airplane branch of the army at the age of 18 and was stationed in England.

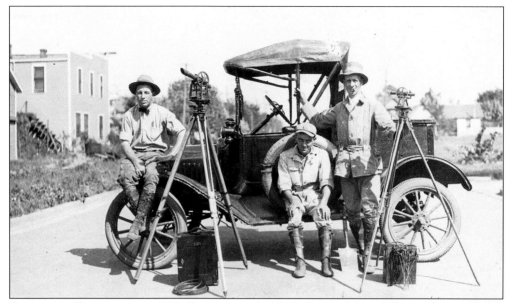

ENGINEERS, BARTLESVILLE, OK, SEPTEMBER 4, 1916. Pictured from left to right are: Ralph E. Slippy, an engineer with Barnsdall Oil Company; Thomas Bevin Hudson; and Elmer J. Sark, chief engineer at the Barnsdall Oil Company and an avid photographer. The company's offices were on the third floor of the Boston Store building located at the southeast corner of Third and Johnstone.

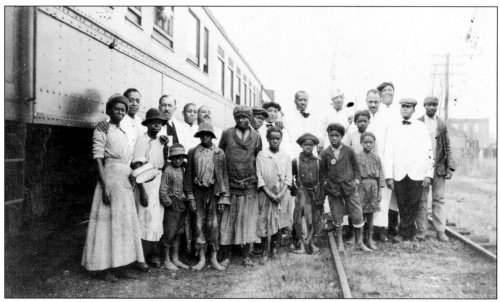

GROUP OF PEOPLE IN FRONT OF TRAIN.

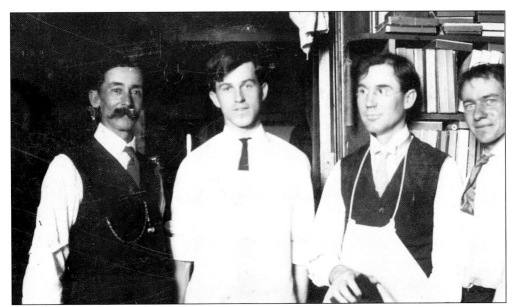

OSCAR DRUM, LORAN C. TWYFORD, B.C. CRAEGER, AND FRANK GRIGGS. In 1904, pioneer photographer Oscar Drum established a tent studio in Dewey for his photography business. When Frank Griggs arrived in 1908, Drum gave him a panorama and a postcard camera. Drum and Griggs became partners in 1910, and in 1913, Griggs formed his own photographic studio. During his lifetime, Griggs took more than 200,000 photographs documenting the growth of Bartlesville and surrounding communities.

PORTRAIT OF MAN AND WOMAN. The woman in this photograph is wearing a muff. Muffs were made of fur or other soft material and used to keep the hands warm. During the early pioneer days, ladies would also hide valuables or conceal weapons inside the muffs hoping to avoid outlaws.

NELLIE JOHNSTONE AND FRIENDS. Nellie is on the far left. Daughter of William and Lillie Johnstone, Nellie was the namesake of the first commercial oil well in Oklahoma. After the Nellie Johnstone No. 1 came in a gusher, the well was capped due to low demand for oil and no way to ship it to refineries. The well was not sealed properly however, and soon began leaking. Many area residents used the overflowing crude for grease or medicinal purposes. Late one winter evening, several local teenagers including Nellie and Walter Coombs, went ice skating on the frozen Caney River when they decided to build a fire to keep warm. Suddenly the flames ignited the leaking oil and followed the flow of crude to the rig, burning it. Years later, Nellie admitted that she was at the river that night.

MR. AND MRS. HADLEY, VERA, OK. The Hadleys built and operated the first store in Vera. Eli Carr was the first postmaster, John Milford the first blacksmith, a man named Mathews was the first banker, Dr. Terrell was the first physician, and Thomas Simcox was the first pastor of the first church, a Quaker mission. Other pioneers were J.W. Chandler, Hugh Watson, J.W. Richardson, and W.R. Mosby.

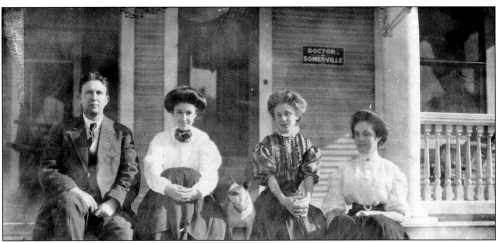

DR. OKEY S. SOMERVILLE FAMILY. Pictured from left to right are: Dr. Okey S. and Gretta Coe Somerville, Jodie (the dog), Rae, and Virginia. Dr. Somerville's family moved to the Bartlesville area around 1905. His practice included Bartlesville, Copan, Dewey, Hogshooter, Ochelata, Oglesby, and Ramona. In 1917, he was instrumental in organizing the medical department of Phillips Petroleum Company.

DAL PETERSON, DILL PETERSON, AND JOHN HOUCHIN. Dal was later a coach at Okmulgee.

RHODES—SEBRING FAMILY. Pictured is Nora Sebring, wife of Charles B. Rhodes, and two of their five children. Charles came to the Cooweescoowee District, Cherokee Nation in 1890 as a school teacher. He was appointed a United States Marshall in 1901 and served in that capacity for many years.

LILA HOOVER, MATOAKA, OK, 1913. Oilfield activity and railroad sidings, providing unloading points for freight and loading facilities for cattle, created or boosted some communities in Washington and Osage Counties. One of these was Matoaka, sometimes spelled without the middle "a." The community, made up primarily of Cherokee families, was settled shortly after the turn of the century when the Cherokee lands were allotted to individual owners.

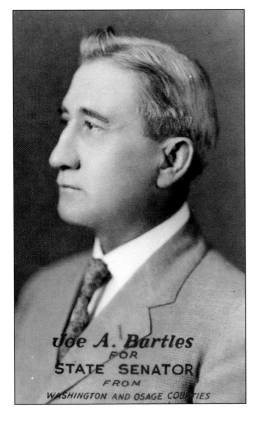

JOE A. BARTLES, BARTLESVILLE, OK, 1924. Bartles distributed these campaign postcards when he ran for the state senate.

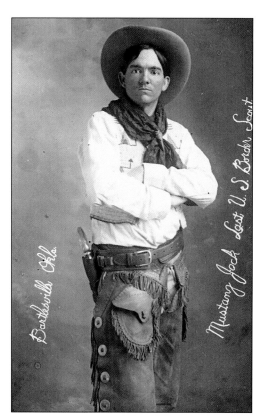

MUSTANG JACK, BARTLESVILLE, OK. Mustang Jack was the last United States border scout.

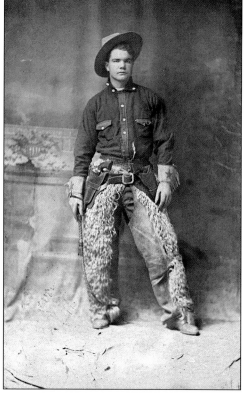

ARDEN OREN HULING. One of six children of Orlando D. and Adalaide P. Pattyson Huling, Arden was born July 23, 1889, in Parsons, Kansas. He married Jessie Austin Barber at Ramona, Oklahoma, on January 1, 1911. They had no children.

FRONTIER COWBOY POSING FOR PORTRAIT. This man is posing in his store-bought Sunday best. His chaps, lariat, six-shooter, and cowboy hat are at rest for the day.

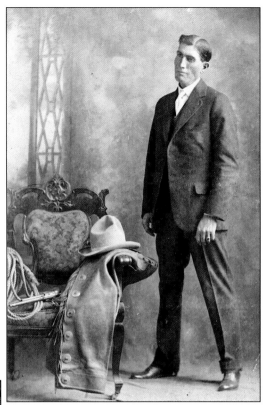

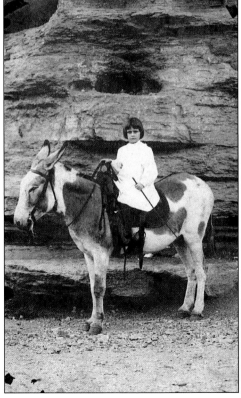

GIRL ON DONKEY. Donkeys were a wonderful means of transportation for children. The donkeys were known for their sure-footedness and their small stature, enabling children to easily mount and dismount the animals.

L.E. Phillips and Rex. L.E. and his dog Rex are pictured on Philson Farms. Philson Farms was developed by L.E. and his son, Phillip R. Phillips.

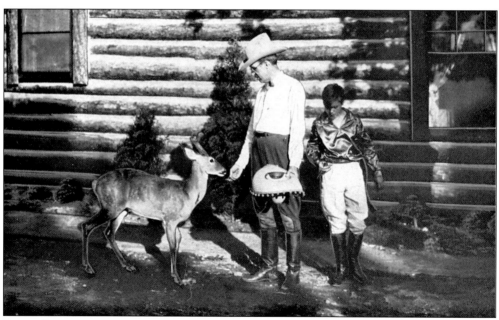

Frank Phillips Feeding Deer at His Ranch. After Frank and his brother L.E. hit the Anna Anderson No. 1, they incorporated the Lewcinda Oil Company in 1906. As oil operations expanded, they formed several other oil companies, eventually consolidating their holdings. In 1917, six wells were drilled—all dry holes, but the seventh flowed 100 barrels daily. The brothers then founded the Phillips Petroleum Company on June 13, 1917.

JANE PHILLIPS AT THE FRANK PHILLIPS RANCH. Married to Frank on February 18, 1897, Jane Phillips was a well-known philanthropist in Bartlesville. When a new hospital opened in November of 1952, it was the result of her efforts. She wanted a children's hospital for the community. When Jane died in 1946, the Frank Phillips Foundation donated $2 million to build the Jane Phillips Episcopal Hospital.

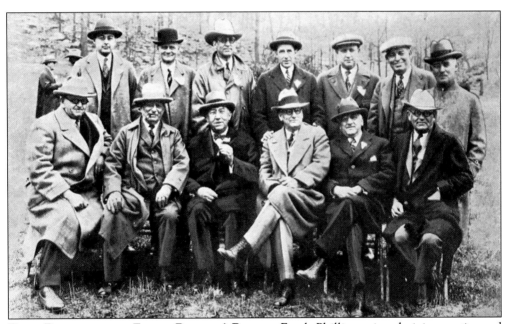

BANK PRESIDENTS AT FRANK PHILLIPS' RANCH. Frank Phillips enjoyed giving parties and entertaining his friends and colleagues at his ranch in the Osage. Shown here are 13 bank presidents at Woolaroc.

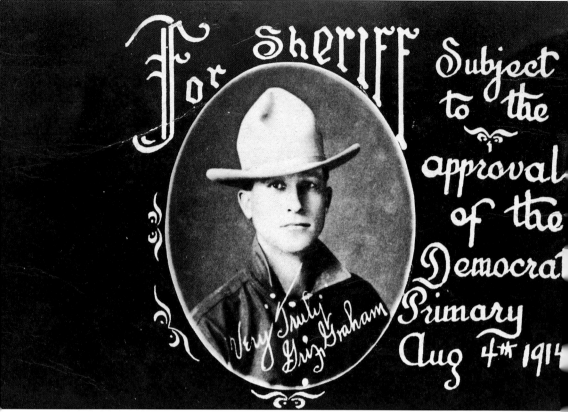

GRIF GRAHAM, BARTLESVILLE, OK. Grif Graham was born February 2, 1879, in Nevada, MO. He was just 13 when his parents, Jonathan and Nannie Graham, came to the Wann area in 1893 where his sister, Lena Graham, was postmistress. When Grif was 26, the family moved to Bartlesville and he went to work for the Caney Valley Planing Mill. In 1909, Grif went to work for John Jordan, the first elected sheriff of Washington County. In 1914, Grif ran for county sheriff and was elected in November on the Democratic ticket. He served in this position for four years.

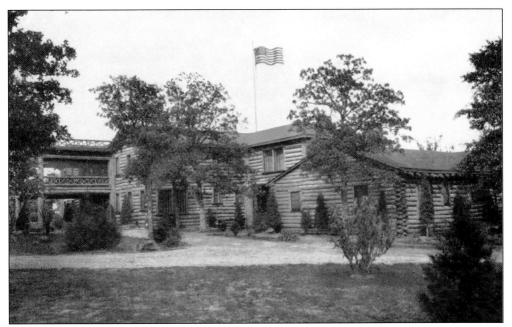

FRANK PHILLIPS' RANCH HOME. Frank Phillips wanted a place in the Osage Hills to relax with his family and friends. The land he chose had favored him earlier with an oil strike. The lodge was built in 1926. The same year, a 3,500-acre wildlife preserve was established with 90 buffalo and 500 wild and domestic animals.

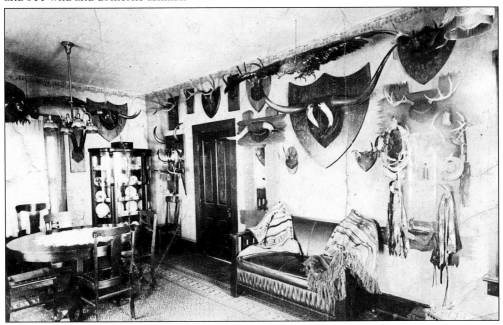

HOME OF GRIF AND ORPHA GRAHAM. When Grif retired from being a sheriff, he went to work for Frank Phillips as caretaker and guide at Phillips' new ranch in the Osage. Grif and his wife, Orpha E. Lewis, lived in a tent on the ranch while the lodge was being built. Both served as hosts to the Phillips' many guests. For more than 25 years, Grif greeted guests with a bright red shirt at the gate and conducted tours of Woolaroc.

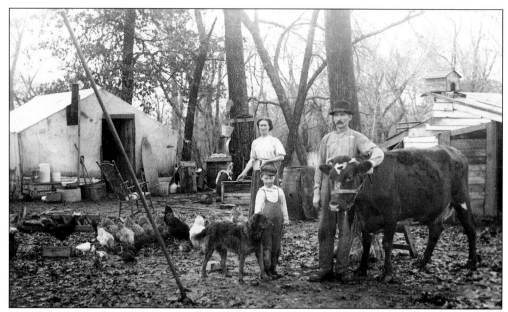

CAMPING IN JOHNSTONE PARK, BARTLESVILLE, OK, C. 1910. The land which became Johnstone Park was originally owned by Nellie V. Johnstone and Howard D. Cannon. On January 13, 1916, the couple signed a deed for 37.09 acres to the City of Bartlesville. The first park employee, hired in 1916, was B.B. Young. During the 1920s, workers were employed six-and-a-half days per week with a salary of $90 a month.

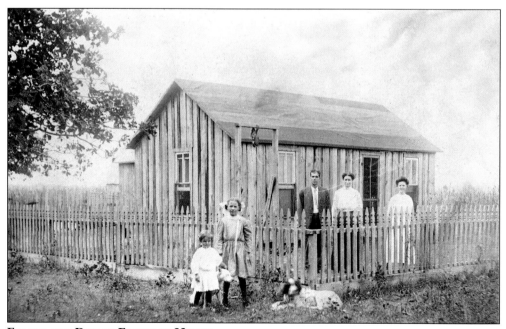

FAMILY AND DOG IN FRONT OF HOUSE.

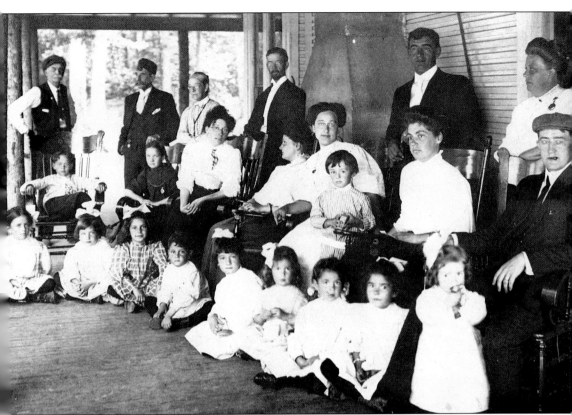

JOHNSTONE FAMILY. The Johnstone family arrived at Coody's Bluff in 1876 when William was just 17. He was employed by Henry Armstrong and in 1882 married Lillie Armstrong. Johnstone worked at Bartles store before forming a partnership with George Keeler and opening a general store on the south bank of the Caney River. The Johnstones were very active in the community. William served as the first school board president, helped organize three banking institutions, was an active member of the Chamber of Commerce and the Baptist Church, and built the Johnstone Building in 1910. After the discovery of oil, he became very active in the development of several leases. Lillie died in 1893, leaving William with three small children. In 1902, William married Stella Bixler and they had one daughter. In 1908, after suffering a heart attack, William disposed of his banking interests, oil properties, and numerous other activities and built a home on Walloon Lake in Northern Michigan. This is where the entire family spent each summer.

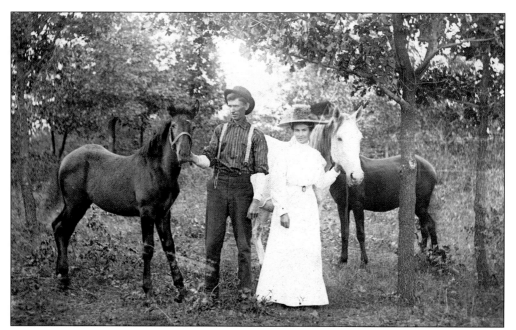

JOHN AND NELLIE BURCH. George E. Wilkinson was a photographer who lived near Dewey in the early 1900s. He took this photograph of the Burches. George came to Oklahoma from Pennsylvania to work in the oil fields. In 1908, he married Mabel E. Hartley and they had a son, Walter, while in Oklahoma. Within a few years, the family returned to Pennsylvania. George died in 1912 leaving Mabel with two small sons.

FISHING TRIP. On the far left is William Johnstone, and next to him is George Keeler. The fish were caught on a fishing trip to Florida.

HUNT, BARTLESVILLE, OK, 1910. Pictured from left to right are Harry Breene, Frank Breene (Harry's son), Emmett, Paul, and W.H. Byrons. The deer was killed by Byrons.

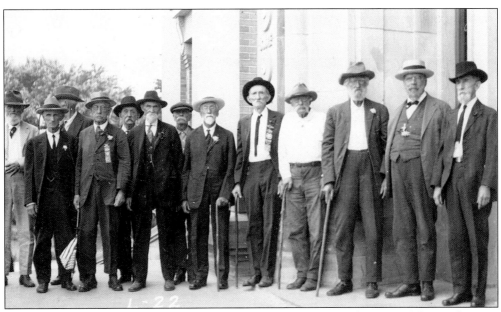

CIVIL WAR VETERANS, BARTLESVILLE, OK, MAY 30, 1922. On the steps of the Washington County Courthouse are Morgan Mattox (second from left), William Higgins, (fourth from left), J.W. Blachly (eighth from left), Richard M. Burch (twelfth from left), and Mr. Gill (thirteenth from left). The others are unidentified.

BIBLIOGRAPHY

Bartlesville Area History Museum archives, vertical files, documents and photographs.

Bartlesville Daily Enterprise, 1913.

Bartlesville Morning Examiner, 1911 and 1921.

Burns, Louis F. *Osage Indian Customs and Myths*. CA: Ciga Press, 1984.

City Directories, City of Bartlesville: 1906–10, 1912–14, 1916–18, 1922–23, 1940, 1942.

Franks, Kenny A., Paul F. Lambert, and Margaret Withers Teague. *Washington County: A Centennial History*. Oklahoma: Oklahoma Heritage Association, 1999.

Lee, Joe. *Memoirs of Ramona, Indian Territory*. 1967.

Oklahoma Today. OK: Oklahoma Tourism and Recreation Department, Summer 1974.

Teague, Margaret Withers. *History of Washington County and Surrounding Area, Vol. I*, OK: 1967.

Teague, Margaret Withers. *History of Washington County and Surrounding Area, Vol. II*, OK: 1968.

Discover Thousands of Local History Books Featuring Millions of Vintage Images

Arcadia Publishing, the leading local history publisher in the United States, is committed to making history accessible and meaningful through publishing books that celebrate and preserve the heritage of America's people and places.

Find more books like this at
www.arcadiapublishing.com

Search for your hometown history, your old stomping grounds, and even your favorite sports team.

Consistent with our mission to preserve history on a local level, this book was printed in South Carolina on American-made paper and manufactured entirely in the United States. Products carrying the accredited Forest Stewardship Council (FSC) label are printed on 100 percent FSC-certified paper.